AMERICAN MODERNS

1910–1960

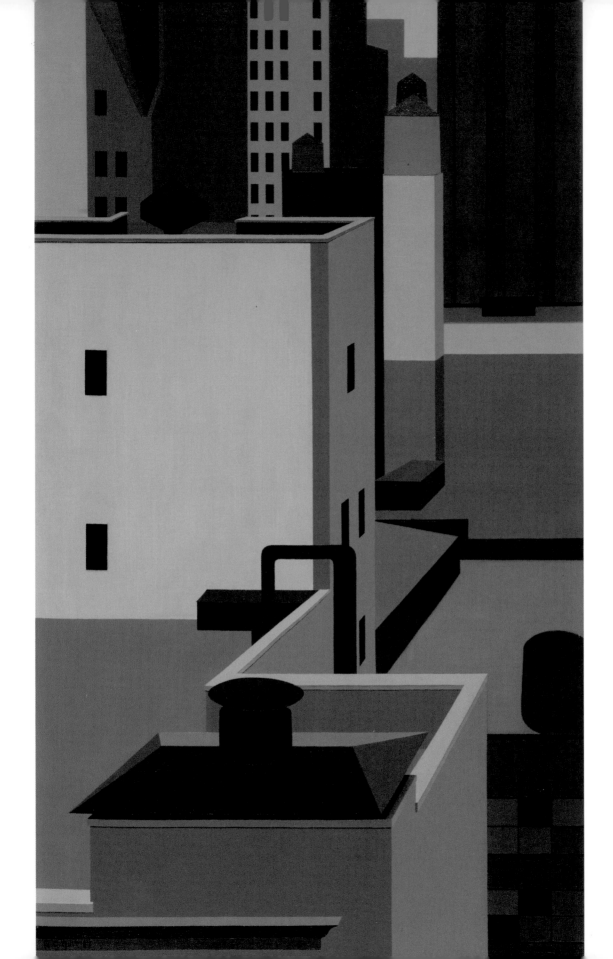

AMERICAN MODERNS
1910–1960 FROM O'KEEFFE TO ROCKWELL

KAREN A. SHERRY WITH MARGARET STENZ

Brooklyn Museum

SAN FRANCISCO

Published on the occasion of the exhibition *American Moderns, 1910–1960: From O'Keeffe to Rockwell,* organized by the Brooklyn Museum.

This publication was supported by a Brooklyn Museum publications endowment established by the Iris and B. Gerald Cantor Foundation and the Andrew W. Mellon Foundation.

EXHIBITION ITINERARY

Oklahoma City Museum of Art
September 27, 2012–January 6, 2013

Everson Museum of Art, Syracuse, New York
February 15–May 12, 2013

Ringling Museum of Art, Sarasota, Florida
June 14–September 8, 2013

Delaware Art Museum, Wilmington
October 11, 2013–January 5, 2014

Reynolda House Museum of American Art, Winston-Salem, North Carolina
February 7–May 4, 2014

Michele and Donald D'Amour Museum of Fine Arts, Springfield, Massachusetts
June 6–August 31, 2014

Wichita Art Museum, Kansas
October 3, 2014–January 4, 2015

Published by Pomegranate Communications, Inc., in collaboration with the Brooklyn Museum.

Pomegranate Communications, Inc.
Box 808022, Petaluma, CA 94975
800 227 1428
www.pomegranate.com

Pomegranate Europe Ltd.
Unit 1, Heathcote Business Centre, Hurlbutt Road
Warwick, Warwickshire CV34 6TD, UK
[+44] 0 1926 430111 I sales@pomeurope.co.uk

Pomegranate Catalog No. A211
Designed by Stephanie Odeh

Brooklyn Museum
200 Eastern Parkway
Brooklyn, NY 11238-6052
www.brooklynmuseum.org

For the Brooklyn Museum: James Leggio, Head of Publications and Editorial Services; Editor: Joanna Ekman.

Photography of Brooklyn Museum objects by Digital Collections and Services, Brooklyn Museum: new photography by Sarah DeSantis and Christine Gant; digitization of historical images by Sarah Gentile.

Library of Congress Cataloging-in-Publication Data
Sherry, Karen A.
 American moderns, 1910–1960 : from O'Keeffe to Rockwell / Karen A. Sherry with Margaret Stenz.
 pages cm
 Includes bibliographical references and index.
 ISBN 978-0-7649-6265-3 (hardcover)
 1. Art, American—20th century—Exhibitions. 2. Art and society—United States—History—20th century—Exhibitions. I. Stenz, Margaret. II. Brooklyn Museum. III. Title.
 N6512.S453 2012
 709.73'07474723—dc23
 2012006789

All catalogue works are in the collection of the Brooklyn Museum. Measurements are given with height first, followed by width and (for sculpture) by depth. Unless otherwise indicated, photographs for figure illustrations were provided by the institutions or owners.

FRONT COVER: Georgia O'Keeffe. *2 Yellow Leaves (Yellow Leaves),* 1928 (page 65). © 2011 Georgia O'Keeffe Museum / Artists Rights Society (ARS), New York

BACK COVER: Stuart Davis. *Pad No. 4,* 1947 (page 97). © Estate of Stuart Davis / Licensed by VAGA, New York, NY

FRONTISPIECE: George Copeland Ault. *Manhattan Mosaic,* 1947 (page 99)

Printed in China
21 20 19 18 17 16 15 14 13 12 10 9 8 7 6 5 4 3 2 1

CONTENTS

FOREWORD

The twentieth century ushered in far-reaching social, technological, and cultural changes that affected nearly every aspect of life in the United States. American art was similarly transformed as artists embraced modern styles and subjects, sought new sources of inspiration, and reconsidered long-standing artistic traditions. *American Moderns, 1910–1960: From O'Keeffe to Rockwell* presents a sampling, drawn from the Brooklyn Museum's world-renowned collections of American art, of striking and diverse paintings and sculptures produced during five groundbreaking decades. These fifty-seven works by forty-two artists, including leading figures such as Milton Avery, Stuart Davis, Marsden Hartley, Grandma Moses, Georgia O'Keeffe, Norman Rockwell, and N. C. Wyeth, showcase the variety and vitality of modern art in America.

The Brooklyn Museum has a long history of supporting both modern and American art. Several pioneering exhibitions took place at this institution, including the first American museum presentation of French Post-Impressionist work (*Paintings by Modern French Masters*) in 1921 and O'Keeffe's first solo museum show (*Paintings by Georgia O'Keeffe*) in 1927. For a century, the Museum has also been at the forefront of exhibitions and scholarship in the field of American art, from colonial to contemporary. Most recently, the major exhibition and catalogue *Youth and Beauty: Art of the American Twenties* (2011) has significantly revised and expanded our understanding of art from that important decade.

Continuing this strong tradition, *American Moderns* marks a focused effort to document our rich American holdings from the first half of the twentieth century and provides a fresh look at these exciting and engaging works.

This exhibition and its accompanying catalogue would not have been possible without the efforts of the Brooklyn Museum's dedicated staff. Teresa A. Carbone, Andrew W. Mellon Curator of American Art, selected the exhibition checklist and guided the project. Karen A. Sherry, Associate Curator of American Art, and Margaret Stenz, former Curatorial Associate, coauthors of this publication, provided texts that combine scholarly expertise with lively insight.

We are pleased that this exhibition will travel to several venues across the country. I extend our thanks to the directors and staffs of those institutions for their commitment to and enthusiasm for the project.

For the ongoing support of the Museum's Trustees, we extend special gratitude to John S. Tamagni, Chair, and every member of our Board. Without the confidence and active engagement of our Trustees, it would not be possible to initiate and maintain the high level of exhibition and publication programming exemplified by *American Moderns, 1910–1960: From O'Keeffe to Rockwell.*

Arnold L. Lehman
Director
Brooklyn Museum

ACKNOWLEDGMENTS

One of the joys of a collections-based project is working closely with the Brooklyn Museum's extraordinary staff. Many individuals helped with the organization of this exhibition and accompanying publication, and it is our great pleasure to acknowledge their contributions. First and foremost, we would like to thank our colleague Teresa A. Carbone, Andrew W. Mellon Curator of American Art, whose initial concept for the project set us on our way. Her guidance and sage insights at every juncture have significantly improved the final product. We are also deeply grateful to the past and present volunteers and interns who performed research and administrative tasks: Charnia Adelman, Caroline Gillaspie, Maria Lokke, Virginia Millington, Sonia Pace, and Alberta Wright. Curatorial Assistants Rima Ibrahim and Emily Sessions handled myriad organizational details with their characteristic skill, efficiency, and enthusiasm.

In the Museum's Library, Sandy Wallace, Library Assistant, Angie Park, Archivist, and Emily Atwater, Archives Assistant, helped to procure key resources and documents. For providing new photography and for obtaining the rights and reproductions for the catalogue, we thank Deborah Wythe, Head of Digital Collections and Services, Sarah DeSantis, Photographer, Sarah Gentile, Associate Archivist, and Alice Cork, Picture Researcher. The works of art were carefully examined and treated by Carolyn Tomkiewicz, Paintings Conservator, and Lisa Bruno, Objects Conservator; their technical analyses contributed greatly to our knowledge of these objects. We are also grateful to Katie Welty, Registrar, and the Museum's team of art handlers for their efforts in ensuring the safe travel of our collections. Sharon Matt Atkins, Managing Curator of Exhibitions, and Dolores Pukki, Exhibitions Coordinator, were instrumental in arranging an exciting roster of venues that allow us to share this exhibition with audiences around the nation.

For their strong support of this project, we are grateful to Arnold L. Lehman, Director, Kevin Stayton, Chief Curator, Ken Moser, Carol Lee Shen Chief Conservator and Vice Director for Collections, and Sallie Stutz, Director of Merchandising. The production of this book was expertly guided by James Leggio, Head of Publications and Editorial Services. At Pomegranate, we thank Katie Burke and Stephanie King for their enthusiasm and support, and Stephanie Odeh for the volume's beautiful design. Finally, we express our profound gratitude to Joanna Ekman, Senior Editor at the Brooklyn Museum, for her patience, astute comments, and thorough editorial work, all of which helped to make this a better publication than it otherwise would have been.

Karen A. Sherry
Margaret Stenz

INTRODUCTION
AMERICAN MODERNS, 1910–1960

The period of 1910 to 1960 witnessed profound changes in American art that mirrored the dramatic transformations wrought by modernization. As the nation began to assert itself on the world stage—economically, politically, militarily—artists increasingly challenged long-standing traditions and institutions by breaking free of established academies and practices. For many, the vanguard art of Europe, including Cubism, Futurism, Expressionism, and other movements, served as a catalyst for their own innovations, while others sought inspiration from the distinctive features of American life. Although inklings of modernism were apparent in America before 1910, modern art attracted widespread attention in 1913 with the landmark International Exhibition of Modern Art in New York—familiarly known as the Armory Show—featuring works by leading international figures of the avant-garde (fig. 1). With the rise of

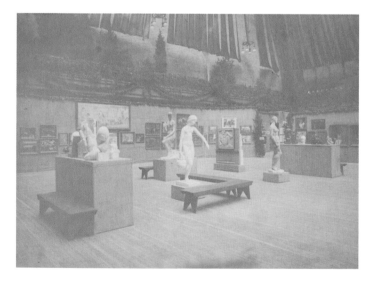

FIG. 1. *International Exhibition of Modern Art, Installation View, at the 69th Regiment Armory, New York, 1913.* Walt Kuhn, Kuhn Family Papers and Armory Show Records, Archives of American Art, Smithsonian Institution, Washington, DC

Abstract Expressionism at midcentury, New York and the United States effectively usurped Europe (particularly Paris) as the recognized center of the art world by 1960, in a shift that paralleled the nation's emergence as a global superpower. *American Moderns, 1910–1960: From O'Keeffe to Rockwell,* which includes selected works from the Brooklyn Museum's world-renowned collections, provides a rich opportunity to trace some of the critical artistic developments of the period.

Modern American art cannot be reduced to one single style or the work of one small group of artists; indeed, it is remarkable for the broad range of subject matter, styles, aesthetic principles, and approaches it encompasses (hence the plural "Moderns" in the title). This diversity is evident in the works of two of the most famous American artists of the twentieth century—Georgia O'Keeffe (1887–1986) and Norman Rockwell (1894–1978)—whose careers span the years of this study. As a painter best known for her powerful abstractions of flowers and other natural forms, O'Keeffe belonged to the avant-garde circle of American modernists promoted by the photographer and gallerist Alfred Stieglitz in New York City before she moved permanently to the Southwest at midcentury. In stark contrast, Rockwell lived in New England, where he worked as an illustrator producing affirmative, hyperrealistic pictures of small-town American life that appeared on the covers of popular magazines. Despite their striking artistic differences, both O'Keeffe and Rockwell created works that eloquently illuminate aspects of the modern experience during these five decades.

This volume and the exhibition it accompanies highlight the breadth and diversity of American art with a selection of fifty-seven paintings and sculptures by more than forty artists who explored what it meant to be modern. Included are works

by many leading artists of American modernism, such as Marsden Hartley, Arthur Dove, and Max Weber; examples of Precisionist painting by George Ault and Francis Criss; Social Realist pictures by Reginald Marsh and Raphael Soyer; the proto-Pop imagery of Stuart Davis; and the popular and folk imagery of Grandma Moses. Instead of appearing in a linear, chronological survey of artistic production, the works are presented in six thematic sections that address some of the dominant preoccupations of American art in this period and compare how different artists addressed them.

The first three sections consider the dramatic changes in style and approach of modern American art in these years. Liberated from academic traditions of narrative and naturalism, many artists embraced novel modes of pictorial expression and reexamined conventional subject matter in order to make it relevant to contemporary life. "Cubist Experiments" focuses on American manifestations of Cubism, which originated in Paris and became the most influential stylistic revolution in Western art of the first half of the twentieth century. Many progressive American artists creatively adapted this style as a new pictorial means of representing objects in space and structuring their compositions. Modern painters and sculptors also revitalized the genre of still-life painting by taking a fresh approach to a centuries-old tradition. "The Still Life Revisited" section explores the myriad ways in which artists used arrangements of everyday objects to experiment with different styles, personal symbolism, decorative compositions, and formal properties of color, form, and space. Nature—landscapes, botanical forms, and other features of the natural world—had long held an important place in American art, as well as in the mythos of America's national identity. "Nature Essentialized" focuses on artists who found artistic inspiration (as well as respite from the city) in the pristine beauty of the seaside, rural locales, and the Southwest. Their encounters with nature prompted stylistic explorations that ranged from realist to abstract, while also offering opportunities for the personal expression of universal and spiritual ideas.

From 1910 to 1960, America was fundamentally transformed through urbanization and industrialization, processes that began in the 1800s but proceeded with unprecedented speed and scope over the next century. The growth of cities provides the thematic material for two sections, "Modern Structures" and "Engaging Characters." As skyscrapers, subways, bridges, factories, and other structures dramatically altered the nation's physical environment, artists found new subject matter and pictorial possibilities in the functional forms, gridlike geometries, and machine aesthetics of the modern world. Many artists were also fascinated by the vast diversity of urban populations, as well as by the new modes of socializing that city living engendered, with its alienation, lack of privacy, and shifting gender roles.

As a counterpoint to sections that explore the dizzying array of changes in modern life and modern art, the final section, "Americana," includes objects that provided a comforting sense of stability in challenging times by nostalgically evoking the past and simpler ways of life. These works of art took two general (and sometimes overlapping) forms: popular imagery rendered in a conventional, naturalistic style; and folk art made by artists who worked independently of the mainstream art world. In both cases, this art capitalized on the nationalism that infused America's sense of cultural, economic, and technological supremacy during the period.

CUBIST
EXPERIMENTS

Widely considered the most influential pictorial vocabulary of the first half of the twentieth century, Cubism was invented in Paris about 1908 by Pablo Picasso (1881–1973) and Georges Braque (1882–1963). The Cubists took a radical new approach to the age-old challenge in Western painting of how to represent three-dimensional form on a two-dimensional picture plane. Rejecting traditional illusionism and inspired by the work of Paul Cézanne (1839–1906) as well as the art of non-Western cultures, these artists fractured an object and its setting into component parts and then reordered these facets across the composition to show multiple, simultaneous viewpoints (fig. 2).

Cubism quickly became an international phenomenon with many practitioners and permutations; its first history, *On Cubism,* by the French painters Albert Gleizes (1881–1953) and Jean Metzinger (1883–1956), appeared in 1912. For the next several decades, artists experimented with this idiom in myriad ways. They incorporated collage elements and hard-edged, flattened shapes (in a style often called Synthetic Cubism) and used different color schemes, decorative effects, and subject matter. Sculptors and architects also explored the approach. Many subsequent artistic movements—or "isms"—owed a debt to Cubism, adapting its stylistic features and artistic principles to their own concerns. For example, Futurism expressed dynamic motion through fragmented planes, Orphism and Synchromism explored the abstract qualities of color through Cubist pictorial structure, and Purism and Precisionism introduced clarity, simplicity, and order to Cubism's fractured geometries.

The Armory Show of 1913 first brought Cubism to the widespread attention of the American public with venues in New York, Chicago, and Boston and with national media coverage. Reactions to this sensational exhibition were mixed; one critic famously ridiculed Marcel Duchamp's (1887–1968) *Nude Descending a Staircase No. 2,* 1912 (Philadelphia Museum of Art), as an "explosion in a shingle factory."[1] For many progressive American artists, Cubism indeed had an explosive impact on their artistic practice by destroying received notions of pictorial representation. This section explores how diverse American modernists achieved innovative results by launching their own Cubist-inspired investigations.

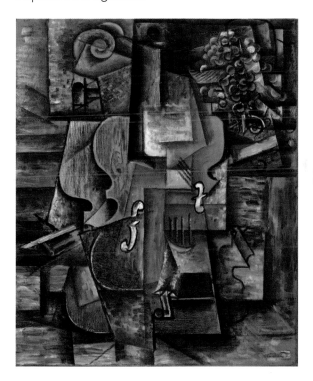

FIG. 2. Pablo Picasso (Spanish, 1881–1973). *Violin and Grapes,* 1912. Oil on canvas, 24 x 20 in. (61 x 50.8 cm). Museum of Modern Art, New York, Mrs. David M. Levy Bequest, 32.1960. © 2011 Estate of Pablo Picasso / Artists Rights Society (ARS), New York. Photo: © Museum of Modern Art / Licensed by Scala / Art Resource, NY

1. This frequently repeated expression was attributed to Dr. Joel E. Spingarn, a former Columbia University professor, in "The Talk of the Day," *New-York Tribune,* Mar. 5, 1913, 8. In 1911, prior to the Armory Show, Alfred Stieglitz (1864–1946) held an exhibition of Picasso's Cubist drawings at his 291 gallery, but it attracted little notice outside of artistic circles.

Marsden Hartley (American, 1877–1943)

Handsome Drinks, 1916
Oil on composition board, 24 x 20 in. (61 x 50.8 cm)
Gift of Mr. and Mrs. Milton Lowenthal, 72.3

With bright, subjective colors and flattened, clean-edged shapes, *Handsome Drinks* depicts a tabletop still life of four drinking vessels: a large, chalice-like goblet in the center, looming over a stemmed glass containing green absinthe, a smaller one with a Manhattan cocktail, and a teacup. Marsden Hartley painted this work shortly after the outbreak of World War I forced him to terminate a stimulating three-year European sojourn, partly financed by Alfred Stieglitz (1864–1946). Hartley's time in Paris (1912–13) exposed him firsthand to the latest developments in European art. There he also frequented the salon of Leo and Gertrude Stein, who hosted gatherings of vanguard artists and writers in their art-filled home. In Germany (1913–15), he befriended Wassily Kandinsky (1866–1944) and Franz Marc (1880–1916), leading German Expressionists who emphasized the spiritual significance of color.

Handsome Drinks shows Hartley's assimilation of these influences in a unique approach that integrates Cubist elements and Expressionist color with personal symbolism. The multiple perspectives (note how the cup and base of the absinthe glass appear to occupy the same plane), as well as the café theme and the lettering in the background, evoke the Synthetic Cubism of Pablo Picasso and Georges Braque. More enigmatic allusions include the almond-shaped mandorla (rising out of the chalice), an object that signifies Christ's holiness in Christian imagery and appears in other works by Hartley. The white block on the table and the letters *LUS* and *LOGH* are equally inscrutable. (Scholars speculate that this text refers to the recently sunk *Lusitania* or to the wordplay of Gertrude Stein's writings, among other interpretations.)[1] In its suggestion of friends gathering for drinks, this painting may also symbolize the camaraderie that the artist enjoyed during this period.

A restless spirit with boundless creativity, Hartley experimented with diverse expressive means throughout his career, making him one of the most original and innovative American modernists. KAS

1. Randall Griffey, Curator of American Art, Mead Art Museum, Amherst, Massachusetts, suggested the *Lusitania* reference in a conversation with the author; for other readings, see Bruce Weber, *The Heart of the Matter: The Still Lifes of Marsden Hartley* (New York: Berry-Hill Galleries, 2003), 27–32.

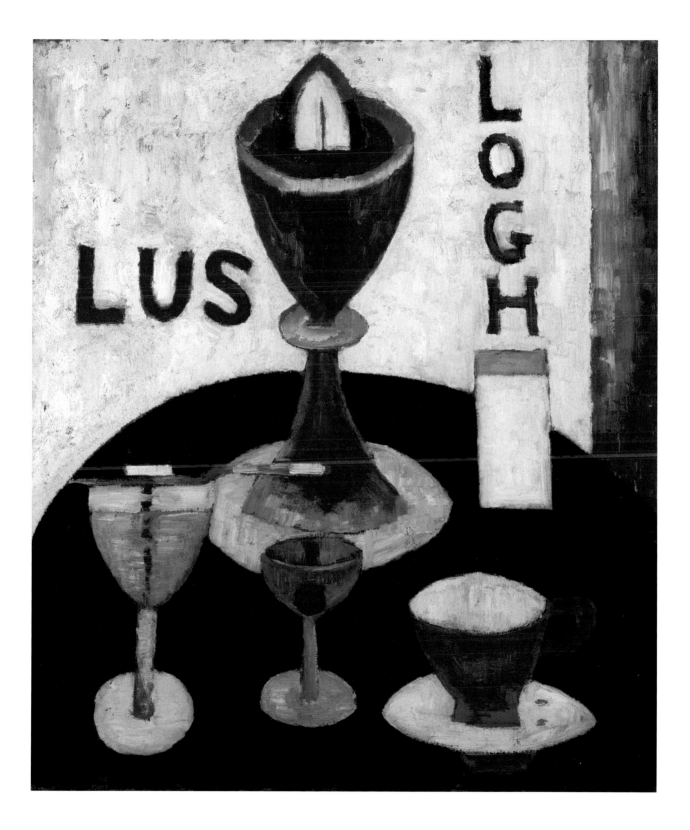

13

Stanton Macdonald-Wright (American, 1890–1973)

Synchromy No. 3, 1917
Oil on canvas, 39 x 38 in. (99 x 96.5 cm)
Bequest of Edith and Milton Lowenthal, 1992.11.24

In *Synchromy No. 3* an interior scene is broken down into a series of faceted fragments and rendered in a kaleidoscopic array of bright colors. The Cubist structure and nonnaturalistic palette make it difficult to discern many of the forms, except for a tabletop still life at center, a slat-backed chair at the lower right, and possibly the leaves of a plant at the left. The title refers to Synchromism, the name Stanton Macdonald-Wright and his friend and fellow American artist Morgan Russell (1886–1953) applied to the brand of Cubism they developed while studying in Paris in 1912. As this term suggests (*synchromy* means "with color"), their main preoccupation was color: they posited that color was the basis of pictorial form, constructing a sense of space and volume based on the relationship between adjacent hues. In developing their principles, they studied color theory in depth and built a kinetic light machine that projected overlapping colored lights; the luminosity of the thinly applied paints in *Synchromy No. 3* suggests such effects. Music also served as an important model: drawing analogies between colors on a spectrum and notes in a scale, the artists believed that colors, like music, could produce visual rhythms and elicit emotional responses.

 The Synchromists debuted their works in Munich and Paris in 1913 and then in New York the following year. Macdonald-Wright continued working in this mode throughout his career, experimenting with pure abstractions and refining his aesthetic theories to include Zen philosophy. After World War I, he settled in Los Angeles, where he became an influential painter, teacher, and leader of artists' professional organizations. KAS

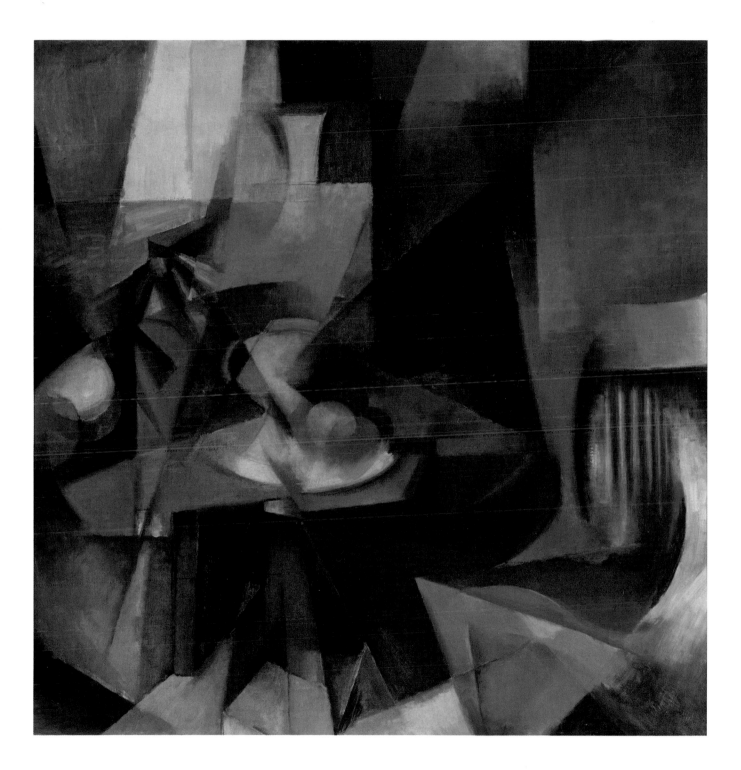

15

Max Weber (American, born Russia, 1881–1961)

The Cellist, 1917
Oil on canvas, 20⅛ x 16⅛ in. (51.1 x 41 cm)
Gift of Mrs. Edward Rosenberg, 78.267

Like *The Visit* (page 19), *The Cellist* exemplifies the most innovative phase of Max Weber's engagement with the Cubist idiom. The subject of a musical performance here provides the opportunity for experimentation with fragmented space, overlapping forms, and rhythms of patterns, shapes, textures, and colors. The cellist's face is elongated and slightly askew—a clear reference to the African masks greatly admired and collected by Pablo Picasso and other modernists (see also Alfred Maurer's *Head of a Girl,* page 23). Other forms are depicted as abstract shapes, lines, and surface textures suggesting wood grain, strings, a sound hole, and pages of sheet music. Just as the pioneering Cubists Picasso and Georges Braque played with words in their many café scenes, Weber included the letters *BAS,* which might suggest a sheet-music cover or allude to a related stringed instrument, a bass. In addition, he explained that his Cubist depictions of musical instruments were made in an effort to combine the senses. In these works he united the visual experience of "two or three objects as if they occupied the same space at the same time" with "the human touch, the spirit and charm of music."[1]

The musical still life was a theme often depicted by the French Cubists, whose canvases Weber knew well during his student years in Paris. Picasso famously created numerous collages and other works portraying guitars between 1912 and 1914, and musicians also appeared in works by Albert Gleizes at this time. These works were not widely known in the United States, though Weber met Gleizes and may have seen Picasso's guitar images on exhibition in New York in 1915.[2] During Weber's lifetime, works such as *The Cellist* were often dismissed as overly derivative of French Cubism, though today they are seen as the most innovative and important works of his career. MS

1. Max Weber, quoted in *Max Weber: Retrospective Exhibition, 1907–1930* (New York: Museum of Modern Art, 1930), 18.
2. Percy North, *Max Weber: The Cubist Decade, 1910–1920* (Atlanta: High Museum of Art, 1991), 42–43.

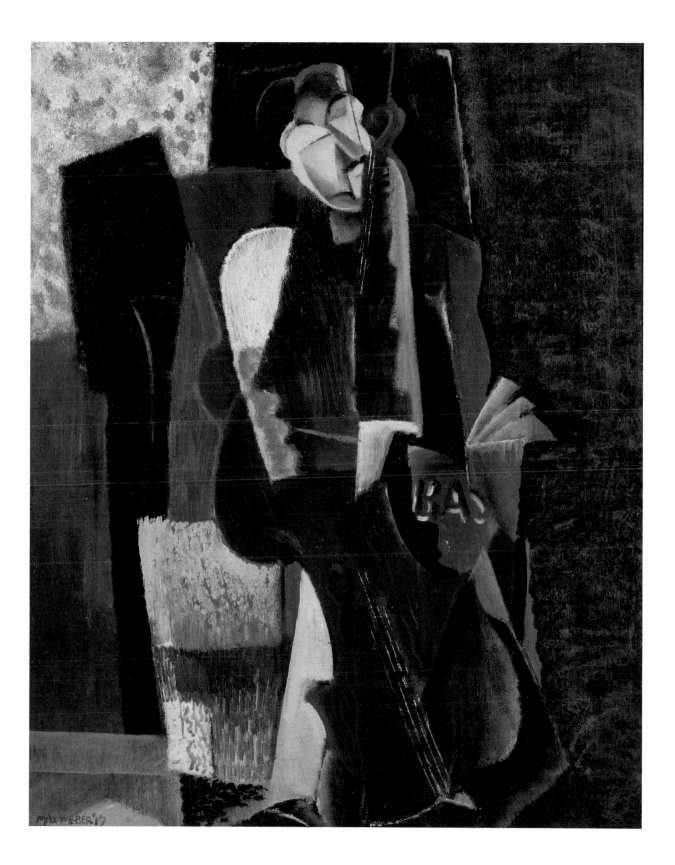

Max Weber (American, born Russia, 1881–1961)

The Visit, 1919
Oil on canvas, 40 x 30 in. (101.6 x 76.2 cm)
Bequest of Edith and Milton Lowenthal, 1992.11.30

The Visit is a decorative Synthetic Cubist version of the traditional conversation piece, an informal group portrait of family or friends, with origins dating to the Renaissance. Max Weber's work is a complex web of shapes, colors, and textures suggesting the visual and tactile elements of the scene. Wavy lines stand for hair; pleats for a dress or upholstery; repeating circles for a lacy or printed blouse. Human arms and legs overlap with those of furniture, and abstract patterns denote a window, a doorway, wallpaper, curtains, and a radiator.

 The Visit may represent a courtship scene[1] or a Sabbath gathering of two couples. In either case, the men's clothing and hats are suggestive of Orthodox Jewish garb, and indeed, this early work seems to record the overlap between Weber's Cubist phase and his later dedication to Jewish subjects, which preoccupied him from 1918 on.[2]

 One of the first Americans to absorb Cubism fully during his student years in Paris, Weber returned to New York in 1908 and embarked on a period of intense stylistic experimentation, executing energetic scenes of New York City streets, buildings, and cafés. Taking up more traditional subjects after World War I, as many American and European artists did, he painted nude bathers—inspired by Cézanne and Henri Matisse (1869–1954)—still lifes, and scenes of Jewish domestic life. MS

1. Lisa Mintz Messenger, "American Art: The Edith and Milton Lowenthal Collection," *Metropolitan Museum of Art Bulletin* 54, no. 1 (Summer 1996): 39.
2. For more on Weber's Jewish subjects, see Matthew Baigell, "Max Weber's Jewish Paintings," *American Jewish History* 88, no. 3 (Sept. 2000): 341–60.

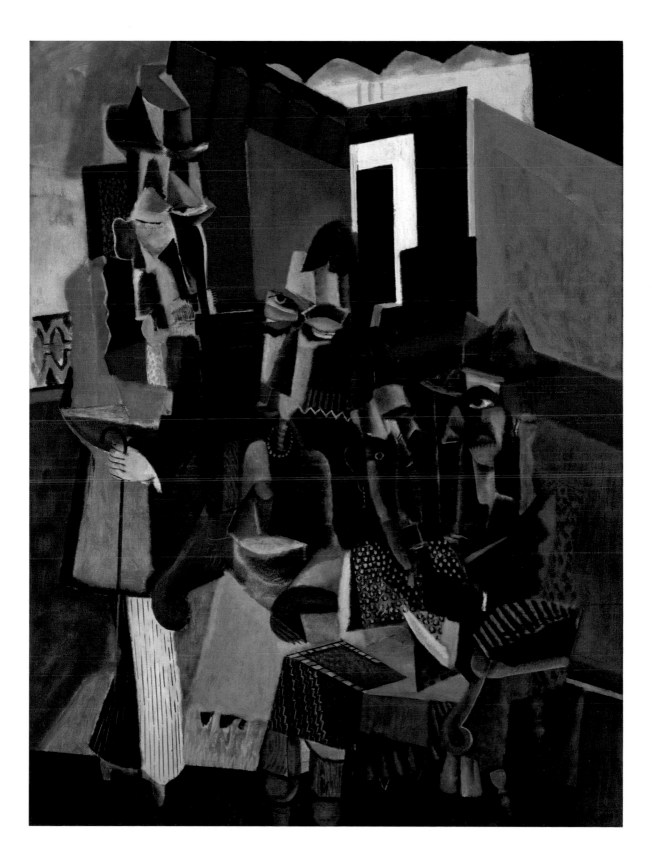

Marguerite Thompson Zorach (American, 1887–1968)

Memories of My California Childhood, 1921
Oil on canvas, 30½ x 25⅛ in. (77.5 x 63.8 cm)
Dr. Robert L. Leslie in memory of Dr. Sarah K. Greenberg, 72.99

Executed in somber, earthy tones, *Memories of My California Childhood* crystallizes a number of intertwined themes in the art of Marguerite Thompson Zorach: family, nature, and her innovative adaptation of Cubism and other modernist styles for expressive purposes. This evocative work was painted shortly after Zorach's yearlong visit to Fresno, California. After a protracted and nearly deadly bout with influenza, she had traveled there from New York to visit her parents with her husband, the artist William Zorach (1887–1966), and their two young children. The painting was based on personal memories but also reflects on the universal theme of motherhood. Seated at the center of the composition with her children fluttering around her, Zorach's mother is portrayed as a source of stability as well as cultivation and learning, as signified by the piano behind her and the book on her lap. Marguerite (in the foreground) and her younger sister, Edith, are seen picking fruit from the overhanging branches, symbolizing the rich abundance of nature, as well as the aspirations of children during their transition into adulthood. Caring for her own children left Zorach little time for her art, but family was very important to her and her husband, as evidenced by the many warm domestic scenes and portraits of family members that appeared in their artworks.

Zorach's fractured, overlapping planes and semi-abstracted shapes, derived from Cubism, are perfectly suited to this distillation of fleeting and fragmentary memories. Though her early works were inspired by the colorful expressions of Henri Matisse and the Fauves, she increasingly turned to Cubism after 1916, perhaps inspired by her friendship with Max Weber; the style offered a unique way to explore motion, multiple perspectives, and time. MS

Alfred Henry Maurer (American, 1868–1932)

Head of a Girl, 1929
Oil on fabricated board, 29¹³⁄₁₆ x 19¹³⁄₁₆ in. (75.7 x 50.3 cm)
Bequest of Edith and Milton Lowenthal, 1992.11.27
© Estate of Alfred Henry Maurer

The colorful and expressively distorted *Head of a Girl* is typical of Alfred Henry Maurer's portrait heads of the 1920s, which feature fractured and elongated faces and oversize, staring eyes. Initially based on young female models, these heads eventually developed into more abstracted and stylized depictions. They display a surprising diversity: some heads are placed against a naturalistic backdrop, while others are rendered in highly fractured Cubist-inspired planes. This head is set against a brightly colored, decorative pattern of overlaid dots and daubs of color.

Along with Pablo Picasso and other modernists, Maurer was strongly influenced by the African masks, sculpture, and other objects that were imported from European colonies and then collected and displayed in shops and museums, such as the Musée d'Ethnographie du Trocadéro in Paris. He adapted their distorted, stylized features both for expressive purposes and as a sign of progressive taste. This interest in African art was a facet of the artistic trend known as "primitivism," whereby modern artists sought inspiration in the art of so-called primitives, including non-Western and indigenous peoples, as a means of revitalizing Western art and flouting its conventions.

Maurer was among the first American modernists who went to Paris to experience the new avant-garde movements there. Although his earliest works incorporated the dark palette and lively Realism of his teachers William Merritt Chase (1849–1916) and Robert Henri (1865–1929), his approach changed dramatically over the course of his fifteen years abroad. With the encouragement of Leo Stein, an American expatriate who owned an exceptional collection of works by Henri Matisse, Paul Cézanne, and Picasso, Maurer developed a unique modernist style that combined the expressive color and simplified compositions of the French Fauves with the rapidly developing Cubist idiom. Maurer returned to New York in 1914, and by the 1920s, he had developed his characteristic subjects—brightly colored and highly simplified still lifes, landscapes, and distorted heads such as this one. MS

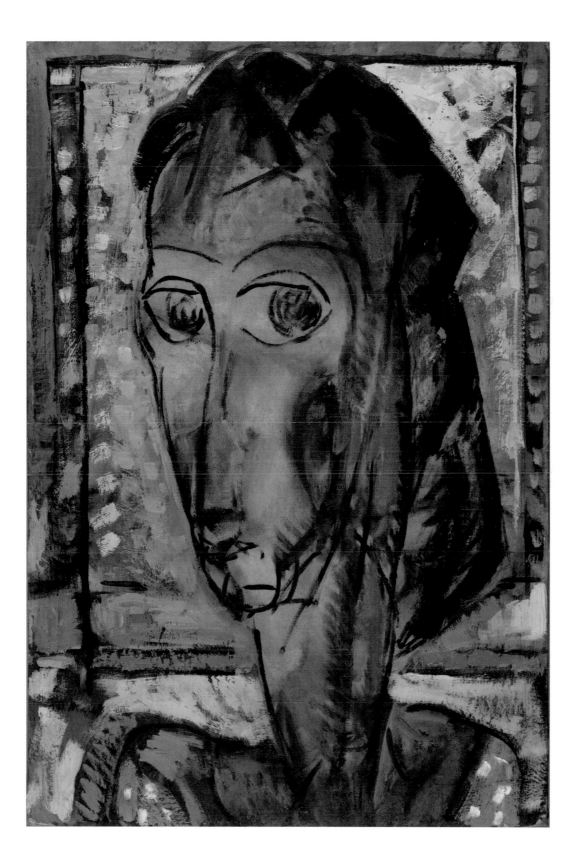

Warren Wheelock (American, 1880–1960)

Abstraction #2, 1920s
Applewood with wood base, 25¾ x 7½ x 5¹¹⁄₁₆ in. (65.4 x 19.1 x 14.4 cm)
Dick S. Ramsay Fund, 46.125

Vaguely suggestive of an elongated figure, an African sculpture, or a plant form, Warren Wheelock's *Abstraction #2* exemplifies the innovative adaptation of Cubism by modernist sculptors. Working with interlocking geometric shapes, the artist created some of the most progressive, nonobjective sculpture of the era. This form, which alternates rounded and hard edges and concave and protruding shapes, highlights the tactile and visual qualities specific to applewood, which was prized by carvers for the quality and colors of its grain.

Wheelock was one of a group of direct carvers who emerged in the United States in the early twentieth century. Working with wood and stone, these sculptors "discovered" the form as it emerged during the process of carving. The technique allowed the artist to be involved with the creative process from beginning to end and to create a unique piece that exploited the natural properties of the material. Direct carving contrasted with more conventional sculpting techniques in which the artist's clay or plaster model was either carved in marble by assistants or cast in bronze at a foundry and often reproduced in multiple versions.

Wheelock began his career as a drawing instructor and commercial illustrator in New York City. While living in North Carolina's Blue Ridge Mountains in the late 1910s, he built his own log cabin, studied folklore, and learned to whittle. After returning to New York in 1922, he worked as a teacher and sculptor and exhibited widely. He experimented with a variety of materials, and his influences ranged from African sculpture to American folk art to European modernism. MS

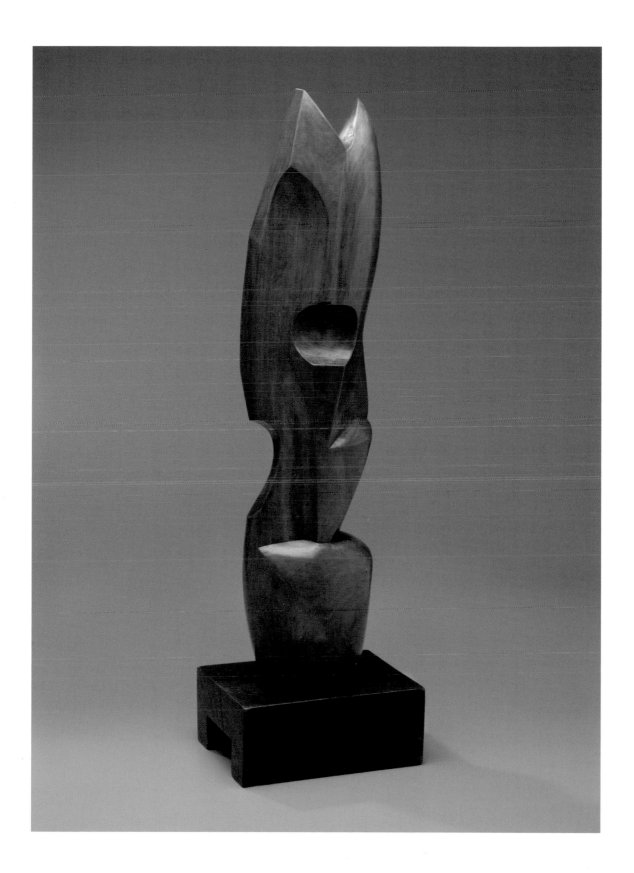

Albert Gallatin (American, 1881–1952)

Composition, 1937
Oil on canvas, 51⅛ x 32¼ in. (129.9 x 81.9 cm)
Gift of Mrs. W. Floyd Nichols and Mrs. B. Langdon Tyler, 54.160
© Estate of Albert Gallatin

Albert Gallatin's simply named *Composition* presents a harmonious arrangement of rectangular shapes and undulating convex and concave forms. Vaguely suggesting the contours of musical instruments or classical architecture and statuary, the painting evokes Purism in its simplicity and reductiveness. An influential variation of Cubism developed by the French artists Amédée Ozenfant (1886–1966) and Charles-Édouard Jeanneret (Le Corbusier, 1887–1965), Purism asserted the beauty and clarity of geometric forms and sought harmony between nature and machines in the wake of the chaos and destruction caused by World War I.

Perhaps one of Gallatin's most pared-down arrangements, *Composition* introduces a highly limited color scheme of earth tones and grays, plus black and white. The shapes are painted with hard-edged precision and surrounded by generous amounts of white space, enhancing the balance and order of the composition.

A collector and art historian, Gallatin began to paint seriously in 1926 while living in Paris. His style was influenced by late Cubism, especially the classicizing works of Pablo Picasso and Juan Gris (1887–1927). In 1927 he installed his seminal collection of European and American modernism at New York University, where he encouraged younger students and artists, including Byron Browne (1907–1961), to spend their leisure time studying modern painting. His Gallery of Living Art had a significant impact on the development of abstract art in America in the 1930s, leading to the formation of the influential group American Abstract Artists, of which Gallatin was a founding member in 1936. MS

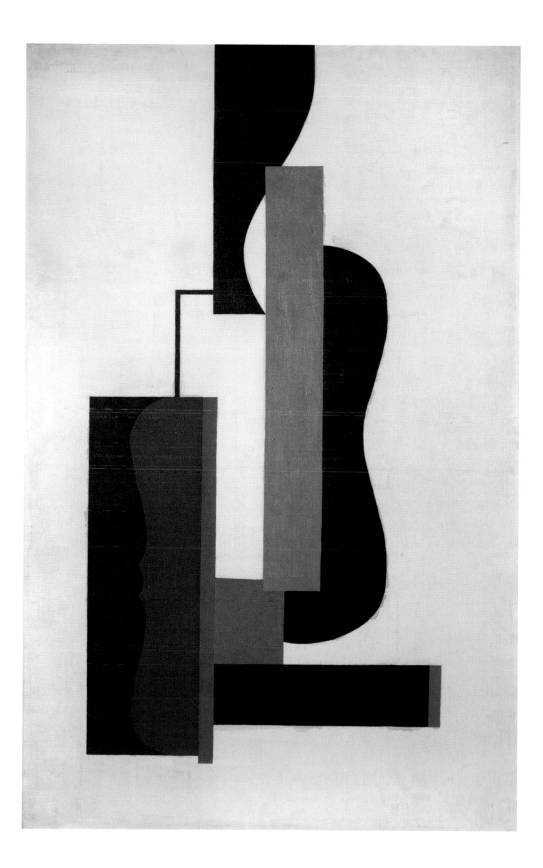

27

George Lovett Kingsland Morris (American, 1905–1975)

Wall-Painting, 1936
Oil on canvas, 45⅛ x 54¼ in. (114.6 x 137.8 cm)
A. Augustus Healy Fund, 73.56
© Frelinghuysen Morris Foundation, Lenox, Massachusetts

Wall-Painting is a witty abstract composition typical of George Lovett Kingsland Morris's interweaving of the flat geometric shapes of Cubism with references to Americana. The title reflects the artist's modernist preoccupation with the painting as a two-dimensional object—an arrangement of colors and forms on a flat surface—rather than as the "window" on reality of traditional easel paintings. Morris modified his

FIG. 3. George Lovett Kingsland Morris (American, 1905–1975). *Study for "Wall-Painting,"* 1936. Oil paint and graphite on paper, 9½ x 12⅝ in. (24.1 x 32.1 cm). Brooklyn Museum, Gift of The Roebling Society in honor of Mrs. Earle Kress Williams, 74.94. © Frelinghuysen Morris Foundation, Lenox, Massachusetts

original conception (fig. 3) of the work by adding sections with floral and other patterns, based on wallpaper samples taken from an old demolished house. The final painting's illusionistically painted wallpapers, wood paneling, and moldings humorously allude to the actual interior walls on which the work would hang, as well as to the early collages of Cubism's founders.

Wall-Painting was completed over the summer and fall of 1936. Later, the dealer Edith Halpert insisted that Morris "freshen up" the painting for his 1944 Downtown Gallery solo show, since clients "always wanted the 'latest.'" He dutifully added "–44" to the date and a layer of glaze to the surface.[1]

Morris's artistic philosophy and his mature style, seen here, were particularly influenced by his teacher Fernand Léger (1881–1955), a French artist who sought to merge modern abstract styles with the classic themes of the past. Countering prevailing attitudes that abstract art was both un-American and elitist, Morris and American Abstract Artists, the group that he cofounded, asserted that an authentic national art could be created by combining the precision, harmony, and rational structure of European Cubism with references to America's unique culture and identity. MS

1. "All rather pointless," he noted, "as she bought it herself!" Painting Record, 73.56 (filled out by artist and dated May 12, 1974), Curatorial file (73.56), American Art, Brooklyn Museum.

Byron Browne (American, 1907–1961)

Variations from a Still Life, 1936–37; reworked after 1951
Oil and gouache on canvas, 46⅞ x 36⅙₆ in. (119.1 x 91.6 cm)
Gift of Mr. and Mrs. Max Rabinowitz, 60.34
© Estate of Byron Browne

A complex arrangement of geometric and biomorphic shapes and lines, *Variations from a Still Life* exemplifies the hard-edged abstractions created by Byron Browne in the 1930s. The forms, suggesting glasses on a tabletop, are reminiscent of the café still lifes favored by the Cubists.

Browne's titles—including terms such as "variation," "arrangement," or "composition"—

FIG. 4. Byron Browne (American, 1907–1961). *Variations from a Still Life,* before reworking (photographed in black and white). Photo: Courtesy of Stephen Browne, Curatorial File (60.34), American Art, Brooklyn Museum

imply an experimental painting process, and in fact this canvas was reworked nearly two decades after it was first executed. At some point after it appeared in the Museum of Modern Art's groundbreaking 1951 exhibition *Abstract Painting and Sculpture in America,* where it represented "expressionist geometric" abstractions (fig. 4), Browne added the brilliant blue triangular sections at the edges, as well as areas of pale pink, green, and ivory. These more transparent or modulated areas contrast with the flatly painted shapes of his earlier works, suggesting the evolution of American abstraction at midcentury.

Browne became committed to abstraction in 1927 after visiting Albert Gallatin's influential Gallery of Living Art, which included examples of the latest European modernism. Browne cofounded American Abstract Artists with Gallatin, George L. K. Morris, Charles G. Shaw (1892–1974), and others. As an abstract artist, he found it difficult to gain commissions from the Works Progress Administration (WPA)—the New Deal agency that hired out-of-work artists to decorate public buildings but favored the realist styles of Regionalism and American Scene painting—though he did execute a large mosaic in Rockefeller Center and an abstract mural for WNYC Radio's Studio D, both in New York. In the 1950s his art began to reflect the influence of Surrealism and the growing importance of Abstract Expressionism. MS

Charles G. Shaw (American, 1892–1974)

Still Life, 1954
Oil on Masonite, 36 x 23¼ in. (91.4 x 59.1 cm)
Gift of Mr. and Mrs. Reginald H. Sturgis, 54.183

A highly decorative abstraction of interlocking and overlapping forms, this painting recalls the café table still lifes of early Cubism, but without the collage elements, wordplay, or faceted, hard-edged shapes. Rather, the primary focus of Charles G. Shaw's *Still Life* is the textural quality of the paint: some sections are thickly and opaquely applied, while others are more lightly layered. With the rough texture of the Masonite support showing through in spots, the surface variations suggest a sense of space and atmosphere.

By the 1950s, Shaw's works, including this one, revealed a nuanced paint application, incorporated secondary colors, such as pale acid yellows and greens, and evoked a psychological mood with references to natural forms.[1] These paintings contrasted with his early productions—flatly painted abstract arrangements and wood relief constructions of geometric or biomorphic shapes that were influenced by the work of the European abstractionists Jean Hélion (1904–1987) and Hans Arp (1886–1966).

Like his longtime friends Albert Gallatin and George L. K. Morris, Shaw came from a privileged background. He first worked as a writer, chronicling Jazz Age high society for magazines such as *Vanity Fair* and the *New Yorker*. While traveling in Europe during the 1920s, he often crossed paths with Gallatin and Morris, who inspired him to take up painting. All three were founding members of American Abstract Artists in 1936 and exhibited frequently with the group throughout their careers. Shaw was also an award-winning poet and a writer and illustrator of children's books, including the classic *It Looked Like Spilt Milk* (1947). MS

1. Howard Devree, "About Art and Artists: Charles Shaw's Paintings at the Passedoit Use Color to Set a Psychological Mood," *New York Times*, Oct. 12, 1954; F. P., "Reviews and Previews: Charles Shaw," *Art News* 53, no. 6 (Oct. 1954): 52–53.

33

Stuart Davis (American, 1892–1964)

Famous Firsts, 1958
Oil on canvas, 44 x 35 in. (111.8 x 88.9 cm)
John B. Woodward Memorial Fund and the Dick S. Ramsay Fund, 59.47
© Estate of Stuart Davis / Licensed by VAGA, New York, NY

In his late paintings, such as this one, Stuart Davis refined his signature style of allover designs of brightly colored, hard-edged shapes (see pages 96, 97) into dramatically simplified compositions. *Famous Firsts* contains a large, irregularly shaped field of golden yellow intersected with jagged red lines and set against a black background with a few white lines. (The artist's signature in bright blue adds the only other note of color to his extremely limited palette.) Although the resulting shapes seem purely non-objective, Davis claimed that this picture "derives essentially from commonplace landscape elements, Air, Perspectives, Color Illusions, Gross Plant Forms, the Mechanical Intrusions of Man, etc."[1] The yellow rectangle with a projecting circle at the upper left suggests an upside-down gas pump, and one of the abstract forms outlined in red at the upper right recalls a leafy treetop; both elements appeared in his earlier landscape *Report from Rockport,* 1940 (The Metropolitan Museum of Art, New York).[2]

Reworking motifs from earlier compositions allowed Davis to reexamine and refine his evolving theories about the formal properties of art—line, color, and the flatness of the picture surface. Many of these concerns stemmed from his enduring preoccupation with Cubism; as he stated, "Cubism is the bridge from percept to concept."[3] Throughout his career, Davis explored new ways of creating pictorial structure through the careful arrangement of different planes of color. With its bold palette, abstracted forms, and flattened space, *Famous Firsts* demonstrates the degree to which Davis adapted Cubism to create his own highly innovative and original idiom. KAS

1. Artist's statement dated Mar. 5, 1959, Curatorial file (59.47), American Art, Brooklyn Museum.
2. According to a note on his calendar, Davis initially sketched the inverted gas pump on the surface of this canvas in November 1956, although he did not continue with the painting until October 1958. See Ani Boyajian and Mark Rutkoski, eds., *Stuart Davis: A Catalogue Raisonné* (New Haven and London: Yale University Press, 2007), 3:427. A similarly shaped gas pump also appears in *Landscape with Clay Pipe* (page 96).
3. Stuart Davis Papers, Fogg Art Museum, Harvard University Art Museums, quoted in Patricia Hills, *Stuart Davis* (New York: Harry N. Abrams in association with the National Museum of American Art, Smithsonian Institution, 1996), 48.

THE STILL LIFE
REVISITED

The still life—generally, an arrangement of food, flowers, vessels, and other inanimate objects—has a long and venerable history in Western art. With roots in ancient Roman wall decorations and Renaissance pictures, this artistic genre became widespread in the sixteenth and seventeenth centuries. Traditionally, still lifes allowed artists to showcase their skills in the illusionistic depiction of diverse materials—the velvety petal of a flower, the transparency of a glass, the bumpy rind of a lemon. Beyond its descriptive function, such imagery of perishable items and other references to time often carried a didactic and metaphysical message: a reminder of the transitory nature of life.

Around the turn of the twentieth century, the French Post-Impressionist painter Paul Cézanne (1839–1906) heralded a radically new approach to the genre with his tabletop paintings of apples, pitchers, and crumpled napkins (fig. 5). Interested in capturing his perceptual and emotional experience of things and their fundamental structures, he represented objects with patches of rich color and from multiple, simultaneous perspectives. Cézanne had a formative impact on modern art in both Europe and America; Marsden Hartley (1877–1943) called him a "prophet of the new time."[1] Following Cézanne's legacy, modern artists largely rejected the conventional aims of mimesis and didacticism and revitalized the practice of still-life painting.

The works featured in this section showcase a range of still lifes produced by American artists.

Taking advantage of the controlled studio environment and immobile objects, many painters used the genre as a vehicle for experimentation. They played with new styles (such as Cubism and abstraction) and explored purely formal concerns and decorative effects (through the manipulation of color, form, and space). Modernist still lifes introduced other innovative ways of looking at objects—as, for example, in the close-up flower paintings of Georgia O'Keeffe (1887–1986). Still other artists invested their compositions with personal symbolism or biographical content through the selection of particular items.

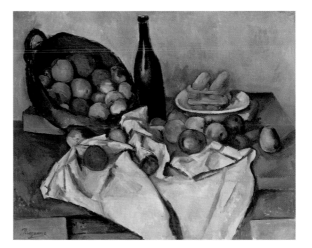

FIG. 5. Paul Cézanne (French, 1839–1906). *The Basket of Apples,* circa 1893. Oil on canvas, 25½ x 31½ in. (65 x 80 cm). The Art Institute of Chicago, Helen Birch Bartlett Memorial Collection, 1926.252. Photo: © The Art Institute of Chicago

1. Marsden Hartley, *Adventures in the Arts: Informal Chapters on Painters, Vaudeville and Poets* (New York: Boni and Liveright, 1921), 36. Hartley also cited the nineteenth-century American poet Walt Whitman as another such prophet.

Maurice Brazil Prendergast (American, 1858–1924)

Flowers in a Vase (Zinnias), circa 1910–13
Oil on canvas, 23¼ x 25³⁄₁₆ in. (59.1 x 64 cm)
Gift of Frank L. Babbott, 39.53

In this painting the Boston artist Maurice Brazil Prendergast rendered a traditional still-life subject—a tabletop flower arrangement—in a progressive manner that emphasizes decorative effect over spatial coherence. The forms of the vase and the zinnias, as well as the table and wall, all appear compressed into a single flat plane, while the surface of the canvas is highly textured. Thick daubs of brightly hued paint and staccato brushwork describe individual flower petals and create a uniform backdrop of parallel horizontal striations. The allover decorative pattern and segmented colors seen here became trademarks of Prendergast's distinctive style, leading critics to compare his paintings to woven tapestries or mosaics.

Flowers in a Vase is one of a series of about twenty-four still-life paintings the artist executed between 1910 and 1913 in a departure from his usual subject matter of leisure scenes set in parks and at the beach. Inspired by recent currents in French Post-Impressionism—in particular, still lifes by Paul Cézanne and Fauvist compositions by Henri Matisse (1869–1954) that he saw on a 1907 trip to Paris—Prendergast began experimenting with a more vivid palette and dynamic paint application in this group of works. One of the first American artists to recognize the importance of European modernism, Prendergast was actively involved in progressive art circles: he exhibited with The Eight (1908) and in the Exhibition of Independent Artists (1910), and he helped to organize the Armory Show (1913). KAS

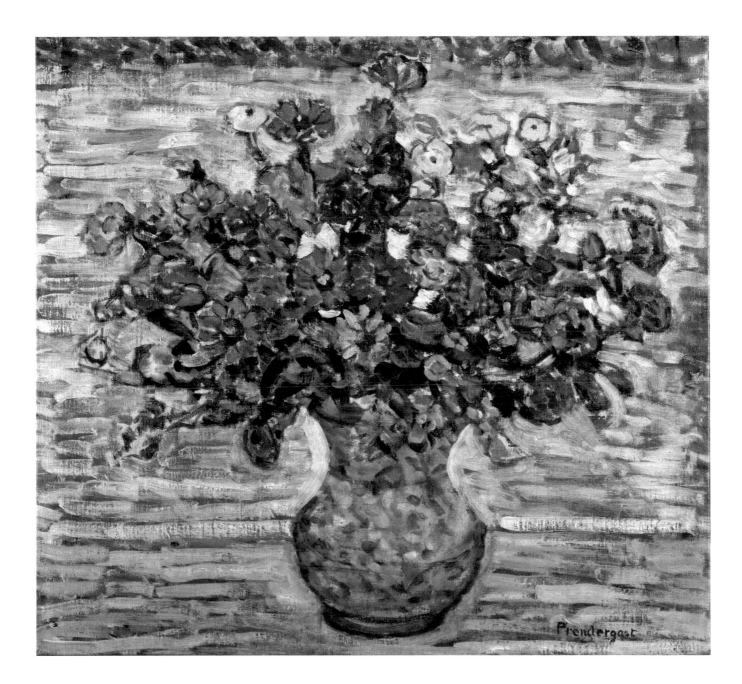

Georgia O'Keeffe (American, 1887–1986)

Black Pansy & Forget-Me-Nots (Pansy), 1926
Oil on canvas, 27⅛ x 12¼ in. (68.9 x 31.1 cm)
Gift of Mrs. Alfred S. Rossin, 28.521
© 2011 Georgia O'Keeffe Museum / Artists Rights Society (ARS), New York

In the early 1920s, Georgia O'Keeffe revolutionized the tradition of the floral still life with paintings of enlarged flowers and other plant forms—one of her signature motifs—that combine realism and abstraction (see also page 65). This example presents an iconic image of a single pansy blossom with a thin stem of forget-me-nots arranged vertically. Removed from either a natural or studio context, the flowers float against a plain, pale blue background. While drastically increasing the scale of the flowers, O'Keeffe reduced the degree of detail in petals, leaves, and stamen. She applied the paint in the smooth brushstrokes and subtle gradations of color that are typical of her style.

The magnification of forms in O'Keeffe's pictures reflects the artist's intense observation and love of nature, as well as her interest in abstract qualities of design and color. As she explained, "When you take a flower in your hand and really look at it, . . . it's your world for the moment. I want to give that world to someone else. Most people in the city rush around so, they have no time to look at a flower."[1] She was also undoubtedly influenced by the close-up photographs of her contemporaries, including Paul Strand (1890–1976) and Imogen Cunningham (1883–1976; fig. 6). Exhibited widely, O'Keeffe's botanical paintings secured her reputation as an innovative modernist. In addition, the suggestive shapes of some of her flowers—evocative of genitalia—led to persistent interpretations of her works in terms of female sexuality and reproduction. KAS

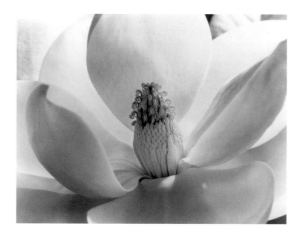

FIG. 6. Imogen Cunningham (American, 1883–1976). *Magnolia Blossoms*, 1925. Gelatin silver print, 9⅛ x 11⅝ in. (23.2 x 29.5 cm). George Eastman House, Rochester, New York. © 1925, 2011 Imogen Cunningham Trust, www.imogencunningham.com

1. Georgia O'Keeffe, quoted in Mary Braggiotti, "Her Worlds Are Many," *New York Post*, May 16, 1946.

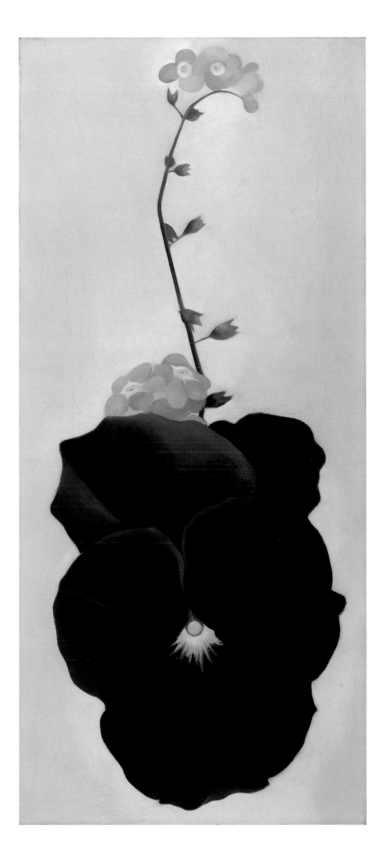

Yasuo Kuniyoshi (American, born Japan, 1893–1953)

Alabaster Vase and Fruit, 1928
Oil on canvas, 36⅛ x 25⅝ in. (91.8 x 65.1 cm)
Gift of Sam Lewisohn, 38.691
© Estate of Yasuo Kuniyoshi / Licensed by VAGA, New York, NY

Painted in an expressionistic style with the artist's characteristic palette of warm browns accented by dark green tonalities, *Alabaster Vase and Fruit* offers Yasuo Kuniyoshi's interpretation of the conventional still life. The sharply uptilted tabletop and the compressed, almost inverted space of a bare corner betray his seamless blend of the spatial distortions of modern European art and the flattened, two-dimensional approach to representation characteristic of Japanese kakemono paintings

FIG. 7. Emma Jane Cady (American, 1854–1933). *Fruit in Glass Compote*, circa 1895. Watercolor, gouache, and mica flakes on paper, 14¾ x 18¾ in. (37.5 x 47.6 cm). American Folk Art Museum, New York, Promised gift of Ralph Esmerian, P1.2001.260

(hanging scrolls) and American folk art. While the black umbrella represents modern life, the selection of objects on the table echoes traditional nineteenth-century theorem paintings that paired grapes, pears, and other native fruits with urns, compotes, or bowls (fig. 7). (These objects appeared in Kuniyoshi's paintings and ink-wash drawings throughout the 1920s.) Like many of his fellow modernists, including Niles Spencer (1893–1952), a close friend since his Art Students League days, Kuniyoshi was an avid collector of American folk-art painting and carving, and early American furniture, dishware, and toys, and such objects are often featured in his paintings.

Kuniyoshi asserted that one of his goals as an artist was "to combine the rich traditions of the East with my accumulative experiences and viewpoint of the West."[1] He came to the United States in 1906 as a teenager, having convinced his parents to let him undertake the voyage, and he initially planned to stay two or three years to learn English.[2] After studying art in Los Angeles and then at the Art Students League in New York, however, Kuniyoshi became fascinated by modern art and American life. Following a short trip to Japan in 1931, he returned to his adopted country, feeling more American than Japanese despite his status as an enemy alien during World War II. MS

1. Yasuo Kuniyoshi, *Yasuo Kuniyoshi* (New York: American Artists Group, 1945), unpag.
2. Ibid.

Niles Spencer (American, 1893–1952)

Camp Chair, 1933
Oil on canvas, 40¼ x 30⅛6 in. (102.2 x 76.4 cm)
Gift of the Edith and Milton Lowenthal Foundation, Inc., 67.182

Camp Chair, a simple studio still-life arrangement of two ears of corn in a white vase, a pedestal with a black drape, a folding camp stool, and a bottle of wine, records Niles Spencer's life and interests during his summers in the art colony of Provincetown, Massachusetts. Executed in his characteristic subdued gray and ocher tones, these ordinary objects are suggestive of personal experience as well as seasonal artistic rituals. The corn and the simplified interior recall the modernists' embrace of the American past and their interest in folk art, colonial portraiture, old barns, and Shaker architecture. The wine bottle evokes the friendship and camaraderie shared by the Provincetown artists and writers, who often gathered for parties at the Spencers' home.

Spencer is perhaps best remembered for his detached, geometrized industrial and architectural New York cityscapes in the style known as Precisionism. During his summers away from the city, however, he specialized in harmonious arrangements (like the one seen here) of small personal objects such as a vase or pitcher, a book, a wine or liquor bottle, and glasses. Many modernists were folk-art enthusiasts, and often a tabletop display of "finds" could be viewed as a personal portrait of the collector. MS

Robert Hallowell (American, 1886–1939)

Poppies, 1934
Oil on canvas, 25⅞ x 20⅞ in. (65.7 x 53 cm)
Gift of Corliss Lamont, 49.171

Poppies is typical of Robert Hallowell's thickly painted, decorative floral still lifes of the 1930s, which were often viewed as his best works. The traditional subject matter and simple composition allowed the artist to explore the reflective qualities of the glass vase, the shadows created on the folded white cloth, and the variegated colors of the flowers. A decidedly modernist approach is found in the ambiguous space and slightly tilted perspective, both reminiscent of Paul Cézanne's still lifes, and in the close-up viewpoint, which cuts off the top and sides of the chair. In addition, the New England ladder-back armchair reflects a modernist interest in folk art and Americana.

Hallowell had studied briefly in his youth at the studio of the prominent book illustrator Howard Pyle (1853–1911) and made occasional illustrations for the *Century*, but financial and family responsibilities prevented him from pursuing a career as an artist. Instead, he began his professional life as a writer and editor, first at the *Harvard Lampoon*, where he oversaw the work of the budding journalist and revolutionary John Reed, and later as cofounder of the progressive journal the *New Republic*.

Hallowell continued to paint during weekends and vacations to France, Spain, Morocco, and Cuba, building up a portfolio of watercolors that he exhibited in 1924 at Galerie Bernheim-Jeune. After this successful show at one of Paris's best-known modern art galleries, he was able to quit his publishing job and devote himself full-time to his art. He established a reputation as a portraitist and illustrator and exhibited widely. MS

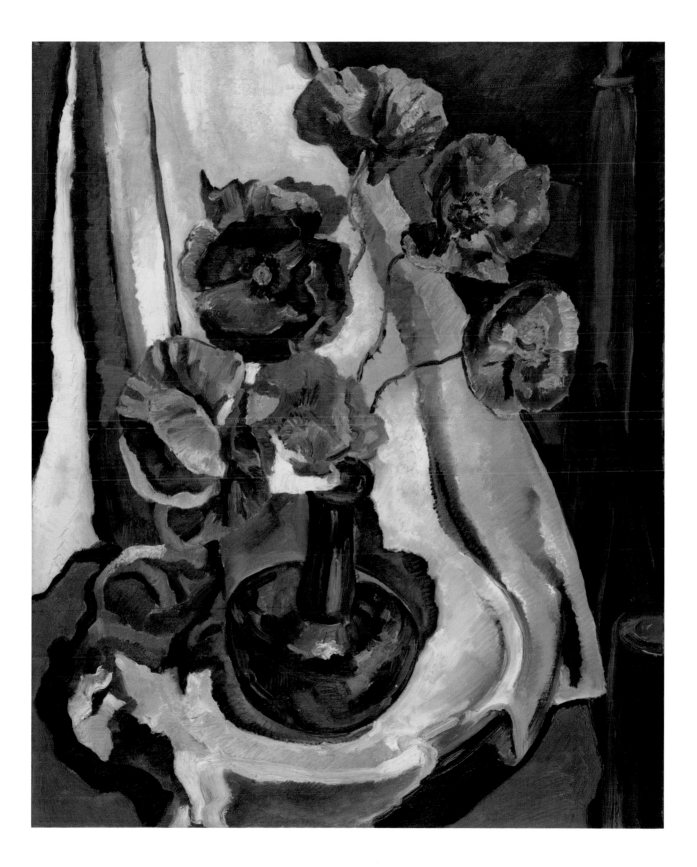

Marsden Hartley (American, 1877–1943)

Sunday on the Reefs, 1935–36
Oil on composition board, 16 x 12 in. (40.6 x 30.5 cm)
Bequest of Edith and Milton Lowenthal, 1992.11.15
© Estate of Marsden Hartley, Yale University Committee on Literary Property

With a vivid palette dominated by shades of bright pink, blue, and white, Marsden Hartley turned this floral arrangement set against the open sea into a study of decorative color effects. He balanced the intense hues of the still life, sky, and ocean with the green and black of the leaves to achieve a rich tapestry of color. Spatial distance between the foreground objects and the background seascape is compressed, creating a sense of overall flatness. Hartley's characteristically rugged brushwork further animates the picture's surface with varied textures.

Throughout a career marked by constant wandering and stylistic experimentation, Hartley returned again and again to flower still lifes. He often defaulted to this subject matter when he felt uninspired by his current surroundings or wanted to delve into the purely formal concerns of his art. In 1935 the artist needed emotional escape after he was forced to destroy more than a hundred paintings because he could not afford the storage costs. To restore his spirits, his dealer sent him to Bermuda, where Hartley reworked the motif of a floral arrangement on a window ledge that he had first developed on a 1917 visit to the island. *Sunday on the Reefs* is one of these later treatments of the subject—which he called "fancies" because they depict flowers from his imagination rather than indigenous flora. More evocative than descriptive, the painting's title suggests a leisurely day in a tropical locale. KAS

Marsden Hartley (American, 1877–1943)

Starfish, 1936
Oil on canvas, 10⅛ x 18⅛ in. (25.7 x 46 cm)
Bequest of Edith and Milton Lowenthal, 1992.11.16
© Estate of Marsden Hartley, Yale University Committee on Literary Property

One of the so-called sea signatures that Marsden Hartley painted while living with the Mason family of fishermen on East Point Island in Nova Scotia, this still life celebrates both the decorative potential and the life force of nature. Four starfish seem to dance across a neutral ground: the undulating shapes of their arms and the slight variations in their arrangements suggest choreographed movement. Hartley emphasized the rough materiality of starfish with thick impasto and bold brushstrokes. In keeping with his style during this period, he also incorporated heavy, dark outlines (sometimes enhanced with a second line of white) in the manner of the French Expressionist painter Georges Rouault (1871–1958), whose works he admired.

 Hartley's time with the Masons had a profound impact on him: he briefly found great happiness in the love and community that had eluded him for much of his difficult life, but he also suffered tragic loss (see page 51). He channeled these experiences into his paintings and writings. In intimate still lifes such as *Starfish*, based on sea-related objects he picked up on beach walks or found in the fishing shack that

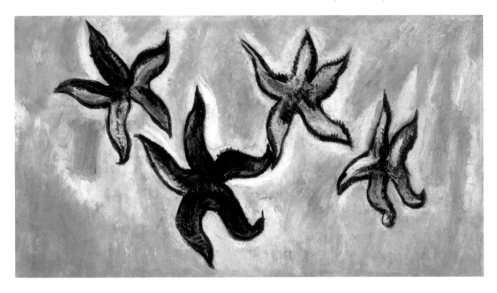

served as his studio, Hartley sought a new intensity of engagement with nature. As he explained, he wanted to "achieve something like myopic observation" so that he could see "minutely and exactly."[1] Always a deeply spiritual man, he also may have considered the starfish—a creature that could regenerate lost limbs—a symbol of his own creative rejuvenation. KAS

1. Marsden Hartley to Adelaide Kuntz, July 29, 1936, quoted in Bruce Weber, *The Heart of the Matter: The Still Lifes of Marsden Hartley* (New York: Berry-Hill Galleries, 2003), 68.

Marsden Hartley (American, 1877–1943)

White Cod, 1942
Oil on composition board, 22 x 28 in. (55.9 x 71.1 cm)
Bequest of Edith and Milton Lowenthal, 1992.11.20
© Estate of Marsden Hartley, Yale University Committee on Literary Property

In *White Cod,* Marsden Hartley invested a pair of common New England fish with his own intense emotions through expressive brushwork. Slashes, scumbles, and scribbles of paint, applied with a heavily loaded brush in dominant hues of white and blue (with touches of pink, lavender, red, and yellow), give the two cod a palpable presence and convincing heft, even though they appear against a spatially nondescript dark background. In the context of Hartley's life and career, these fish represent a "homecoming" of sorts. From 1937 to his death, as he began spending longer periods of time in his native Maine, the site of his painful childhood, he regularly depicted marine creatures, fishermen, and other subjects associated with the region's fishing industry. *White Cod* also revisits his early training with William Merritt Chase (1849–1916) in New York. Chase assigned fish still lifes to his students as challenging exercises in the representation of form and color.

On a symbolic level, the pair of dead fish most likely alludes to the 1936 drowning of Hartley's beloved friends Alton and Donald Mason, sons of a Nova Scotia fishing family with whom he lived during the summers of 1935 and 1936. *White Cod,* with its emblematic presentation and somber palette, links the Mason boys' deaths to Christ's martyrdom through the traditional Christian symbolism of the fish. In this respect, the artist transforms the traditional allegorical function of still life as a memento mori, a reminder that all living things must die, into a deeply personal memorial. KAS

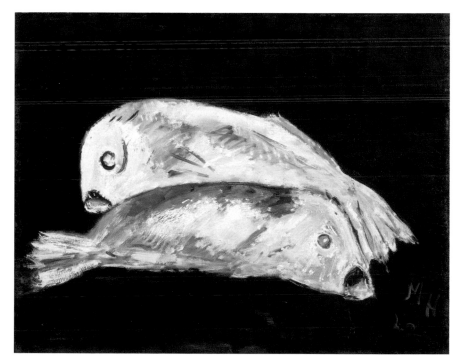

Georgia O'Keeffe (American, 1887–1986)

Fishhook from Hawaii—No. I, 1939
Oil on canvas, 18 x 14 in. (45.7 x 35.6 cm)
Bequest of Georgia O'Keeffe, 87.136.2
© 2011 Georgia O'Keeffe Museum / Artists Rights Society (ARS), New York

Even the immensely successful Georgia O'Keeffe was not immune to the financial hardships of the Great Depression. In 1939 she accepted a commission from the Dole Pineapple Company to make imagery for an advertising campaign and spent three months in Honolulu and Maui, Hawaii. Although Dole never used her work, she took full advantage of the visit, creating a number of botanical still lifes and landscapes inspired by the lush tropical scenery. *Fishhook from Hawaii* is among the most daring pictures from this trip.[1] Rendered in her distinctive style of blown-up, simplified forms and carefully modulated hues, it depicts a colorful, feathered fishing lure, with its coiled line, suspended in a compressed foreground space against a broad expanse of cerulean blue sea and sky. The backdrop is fractured into a series of overlapping circular views framed by the loops of the wire, creating a telescoping effect at the center of the composition that suggests movement across both space and time. O'Keeffe further explored this new interest in spatial distortions and dramatic juxtapositions of near and far several years later in a series of paintings begun in 1943, in which a glimpse of distant sky or southwestern desert landscape is seen through the openings of an animal bone placed in the foreground. KAS

1. There is a second version of this subject at the Museum of Fine Arts, Boston: *Fishhook from Hawaii—No. 2,* 1939 (acc. no. 1987.540).

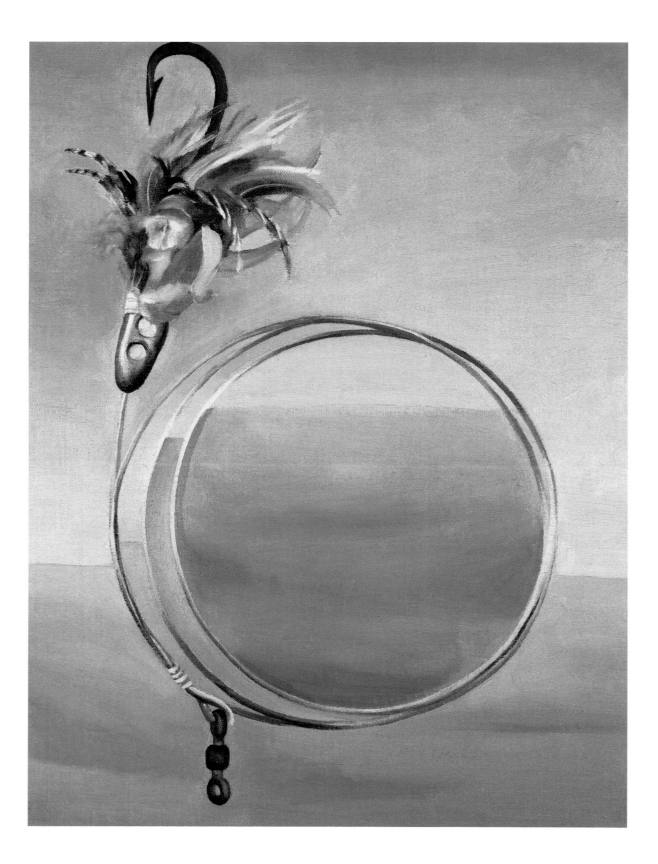

Robert Brackman (American, born Russia, 1896–1980)

Still Life with Discarded Pitcher, circa 1940
Oil on canvas, 45 x 51 in. (114.3 x 129.5 cm)
Gift of Alfred W. Jenkins, by exchange, 41.1084
© Estate of Robert Brackman

Robert Brackman's naturalistic style and range of subject matter (including portraits, nudes, and still lifes) were both conventional. He painted many variations of the arrangement seen here—a selection of fruits, a crumpled cloth, and a white porcelain pitcher, all set on a table against an austere gray background. For Brackman, as for Paul Cézanne, whom he admired, still life allowed an exploration of "the abstract qualities of color and tone rather than the pictorial interest of the subject."[1] Brackman crafted his images less through line than through the careful manipulation of different color intensities. In *Still Life with Discarded Pitcher*, for instance, he used a range of red values, applied in light touches, to describe the apple at lower left. Each individual object has a palpable presence yet is fully integrated into a coherent surrounding space. The artist's interest in compositional design is evident through a sophisticated play of shapes and textures. The rounded contours of the fruit echo the undulating curves of the pitcher and, in turn, contrast with the straight-edged geometries of the table, while the hard surfaces of ceramic and wood set off the soft fabric of the fringed tablecloth.

Although Brackman's realistic paintings seemed out of step with contemporary artistic trends, he won high praise for his craftsmanship throughout his career. As an influential teacher at the Art Students League in New York from 1934 to 1975, as well as at his summer school in Noank, Connecticut, and other venues, he also emphasized technique, encouraging students to emulate past masters—such as Titian (1488–1576), Frans Hals (1580–1666), José de Ribera (1590–1652), and Édouard Manet (1832–1883)—in order to obtain a rigorous understanding of the craft of painting. KAS

1. Robert Brackman, quoted in Ernest W. Watson, *Color and Method in Painting as Seen in the Work of 12 American Painters* (New York: Watson-Guptill Publications, 1942), 104.

George Biddle (American, 1885–1973)

Giant Crab, 1941
Oil on Masonite, 16 x 20 in. (40.6 x 50.8 cm)
Gift of Constance and Henry Christensen III, 2010.3.3
© Estate of George Biddle

Greatly enlarged and tipped upward, the cooked Dungeness crab depicted in this simple arrangement assumes a monumental, vivid presence. Applying paint in thin layers, George Biddle realistically described the crustacean's distinctive shape, bumpy textures, and mottled coloring with carefully modulated hues and with accents of incised lines and touches of impasto. The bright reddish orange of the crab's shell stands out against both the cool colors of the dish and napkin and the muted gray and sage green of the background. To heighten this meal's sensory immediacy, Biddle tilted the perspective and compressed the space (the wall and table seem to occupy the same plane), closing the distance between object and viewer.

Painted in Southern California, *Giant Crab* is one of a series of still lifes reflecting the regional foods and products that Biddle encountered on his extensive travels. His training and journeys exposed him to a range of academic and modern approaches to art, but a 1928 sketching trip in Mexico with Diego Rivera (1886–1957) was particularly formative. Inspired by the Mexican muralist, Biddle became committed to making art that had both accessible, realistically depicted subject matter and social relevance for Americans; he also became a leading champion of government support for artists. (His proposal to President Franklin Delano Roosevelt, an old school chum, evolved into the Federal Arts Program of the Works Progress Administration [WPA].) In his frequent writings on art, Biddle denounced extreme forms of modernist abstraction—what he called "empty and pretentious slibber-slobber"[1]—as elitist and un-American because of its European influences. KAS

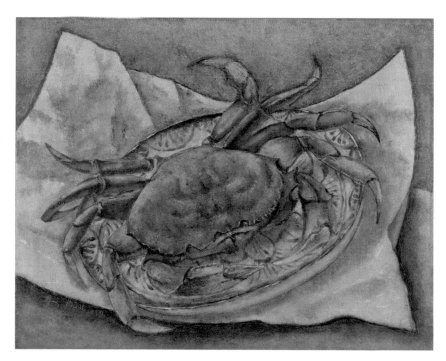

1. George Biddle, "Modern Art and Muddled Thinking," *Atlantic Monthly* 180 (Dec. 1947): 60.

NATURE
ESSENTIALIZED

While some artists embraced imagery of America's cities and industrial structures, many American modernists turned to nature for their subject matter, finding artistic inspiration in the organic beauty of landscapes, seascapes, flora, and fauna. Among their diverse motives was the belief that nature provided escape from the physically and psychically exhausting effects of urban life, as well as the opportunity for spiritual restoration. Although the business of art was generally conducted in cities in proximity to exhibition venues, dealers, and patrons, many artists spent part of the year working in the country, at the shore, or in some other far-removed locale. Formal and informal artists' colonies in such places as Provincetown and Gloucester, in Massachusetts, and Taos, in New Mexico, provided both respite and camaraderie during the summer months. Another reason for the modernist preoccupation with natural forms was the long-standing identification of America (and American character) with its distinctive wilderness. The mid-nineteenth-century Hudson River School of landscape painters had also embraced this idea, though twentieth-century artists generally eschewed earlier naturalistic styles that had favored topographical or atmospheric veracity over other pictorial concerns.

The works featured in this section offer a diverse array of nature subjects—panoramic vistas, botanical studies, creatures of the forest and the sea, and the occasional human figure integrated into a landscape. Some artists sought to reveal nature's vital essence and universal rhythms by stripping away extraneous details, creating organic abstractions that reflected the modernist aesthetic of simplified forms. Natural imagery also served as a vehicle for the exploration of purely formal relationships of color, shape, and space. Many artists expressed their subjective responses to natural motifs, investing their pictures with personal and biographical symbolism in order to reestablish a deep spiritual connection with nature in the face of rampant modernization.

Rockwell Kent (American, 1882–1971)

Down to the Sea, 1910
Oil on canvas, 42½ x 56¼ in. (108 x 142.9 cm)
Gift of Frank L. Babbott, 25.758

Under a cerulean sky dotted with clouds, a number of figures gather on the beach, their

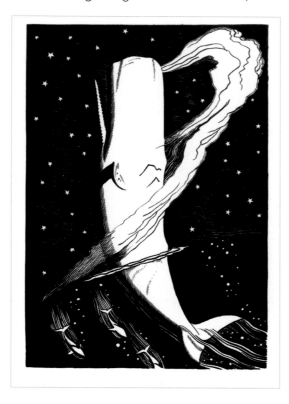

FIG. 8. Rockwell Kent (American, 1882–1971). [Nighttime scene with whale and stars], original illustration for Herman Melville, *Moby Dick* (Chicago: Lakeside Press, R. R. Donnelley & Sons, 1930), 1930. Pen and ink on paper, 10⅛ x 7¹⁄₁₆ in. (25.7 x 17.9 cm). Spencer Collection, New York Public Library, Astor, Lenox and Tilden Foundations. © Plattsburgh State Art Museum, State University of New York, Rockwell Kent Collection, Bequest of Sally Kent Gorton

upright stances echoed by the tall masts behind them. The frieze of men in dark clothing, accentuated by the dark shadows and the coffin-shaped boxes in the foreground, suggests a funeral procession. The air of sadness is countered, however, by the warm embraces of the female figures in white, the man joyfully playing with his dog, the line of sunlight on the beach, and the vivid colors of the sea and sky.

Down to the Sea was inspired by the simple but heroic lives of the fishermen whom Rockwell Kent befriended while living for several years on the wild and sparsely populated Monhegan Island, off the coast of Maine. The ambiguous narrative—is this a sad departure or a joyous homecoming?—and the small scale of the figures against the backdrop of nature suggest the continuity of life even in the face of death. The title alludes to a biblical verse: "They that go down to the sea in ships, that do business in great waters; / These see the works of the LORD, and his wonders in the deep" (Psalms 107:23–24).

Kent was drawn throughout his life to remote locations, where he sought inspiration in the stark beauty and the austerity of nature. A writer of travel adventures as well as a painter and illustrator, he held a lifelong interest in seafaring mythology. His famous 1930 illustrated edition of Herman Melville's *Moby Dick* (1851) helped to make the novel the classic it is today (fig. 8). MS

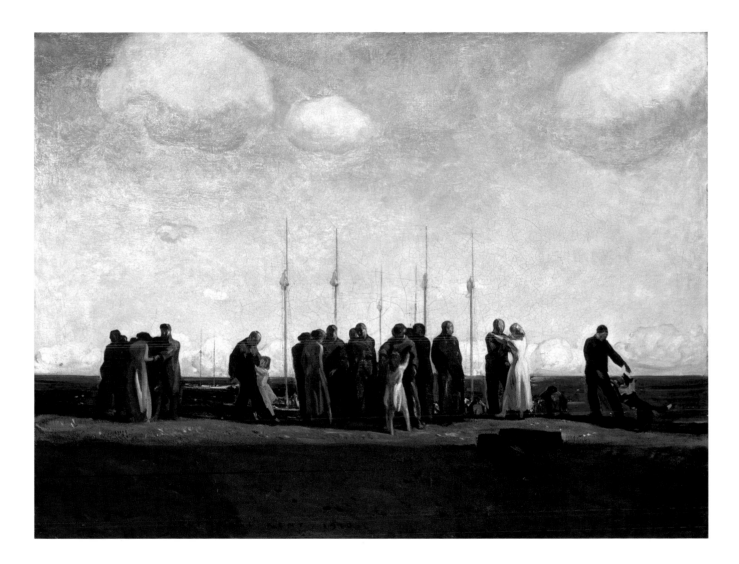

Elie Nadelman (American, born Poland, 1882–1946)

Resting Stag, circa 1915
Bronze with marble base, 15½ x 20⅝ x 10 in. (39.4 x 52.4 x 25.4 cm)
Bequest of Margaret S. Lewisohn, 54.158

"I employ no other line than the curve, which possesses freshness and force," Elie Nadelman wrote in 1910. "I compose these curves so as to bring them in accord or opposition to one another. In that way I obtain the life of form, i.e. harmony."[1] The artist fully realized his vision of the harmonious opposition of curving forms in this sculpture of a reclining stag. The animal is rendered in a series of sinuous, stylized contours that are both naturalistic and decorative, generalized and particular. A tension also exists between stasis and animation: the stag's rigid pose is countered by the dynamic twist of its head as the animal turns to lick a hind leg. The serpentine antlers and attenuated legs add to the work's appealing elegance.

Nadelman was well established in European avant-garde circles when the outbreak of World War I forced him to flee to America. There, he refined his earlier, classicizing style to a more simplified, archaizing one, exemplified in this sculpture. His interest in folk and prehistoric art (in 1911 he visited the cave paintings in the Dordogne region of France), as well as the streamlined aesthetic of the machine age, inspired this stylistic shift. His 1917 exhibition in New York of figural and animal sculptures—including *Resting Stag*—catapulted him to success in his new country. Although Nadelman continued sculpting in various media, in the 1920s he increasingly devoted his efforts to amassing a large collection of American folk art. KAS

1. Elie Nadelman, "My Drawings," in "Photo-Secession Notes," *Camera Work,* no. 12 (Oct. 1910): 41.

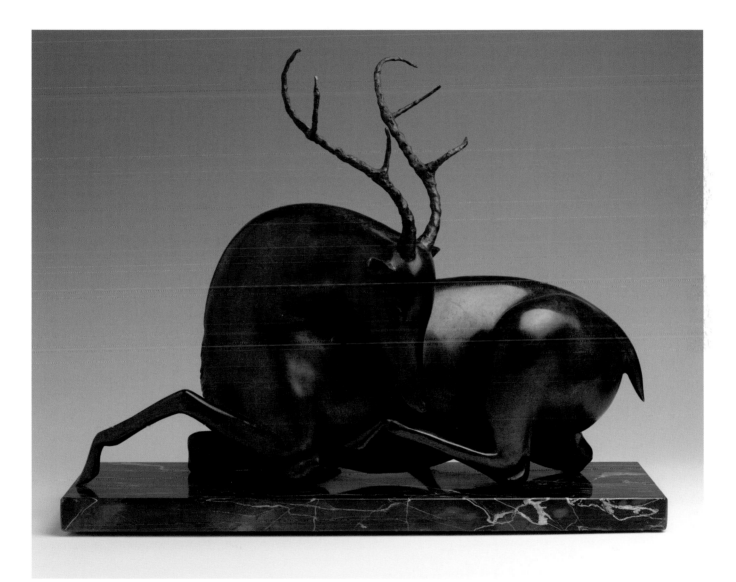

Joseph Stella (American, born Italy, 1877–1946)

The Virgin, 1926
Oil on canvas, 39¹¹⁄₁₆ x 38¾ in. (100.8 x 98.4 cm)
Gift of Adolph Lewisohn, 28.207

With richly saturated colors and an abundance of botanical decoration, Joseph Stella endowed his image of the Virgin Mary with iconic power and spiritual mystery. Framed within an arch of fruits, flowers, and fanciful birds and wearing an embellished blue robe, the Madonna stands

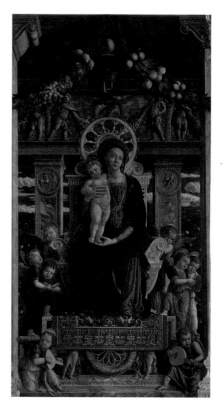

FIG. 9. Andrea Mantegna (Italian, circa 1431–1506). *Enthroned Madonna and Child with Angels* (central panel from the San Zeno Altarpiece), 1457–59. Oil on panel, 86⁹⁄₁₆ x 45¼ in. (220 x 115 cm). Basilica of San Zeno, Verona, Italy. Photo: Scala / Art Resource, NY

serenely with eyes closed and hands crossed in prayer against a distant backdrop of the Bay of Naples. Although the painting's approach is generally realistic, Stella abstracted the natural forms into crisply delineated, simplified shapes with minimal details and subtle modeling, particularly in the figure's face, hands, and body contours. For Stella, the garland of fruits and flowers—conventional symbols of the Madonna's fertility—also signified his own creativity.

Inspired by the natural beauty and artistic heritage of his native Italy, Stella made a series of paintings of the Virgin Mary. In both religious subject matter and archaizing style, his modern Madonna recalls the Early Renaissance pictures and popular devotional imagery that he saw while traveling there in 1926 (see, for example, fig. 9).[1] Stella gushed, "The beauty which smiles all around, here, in Italy, from innumerable masterpieces, [spurs] me to create a new Beauty equal in power to the old one."[2] His "new Beauties," which included his paintings of the Virgin as well as of mythological goddesses and other heroic women, constitute a drastic departure from earlier works that celebrated the modern wonders of his adopted New York (such as Coney Island and the Brooklyn Bridge) in a Cubo-Futurist idiom. In the 1920s Stella was among many American and European artists who turned to more traditional subjects and naturalistic styles in response to the disillusionment caused by World War I. KAS

1. In his autobiography, Stella claimed that he painted *The Virgin* in 1922, on an earlier trip to Italy. The artist regularly falsified dates (including the year of his birth), and art historians now believe that he created this work in 1926.
2. Joseph Stella to Katherine Dreier, Sept. 26, 1926, quoted in Barbara Haskell, *Joseph Stella* (New York: Whitney Museum of American Art, 1994), 150. Dreier was a director of the Société Anonyme in New York, an organization founded in 1920 and devoted to the promotion of vanguard art in America.

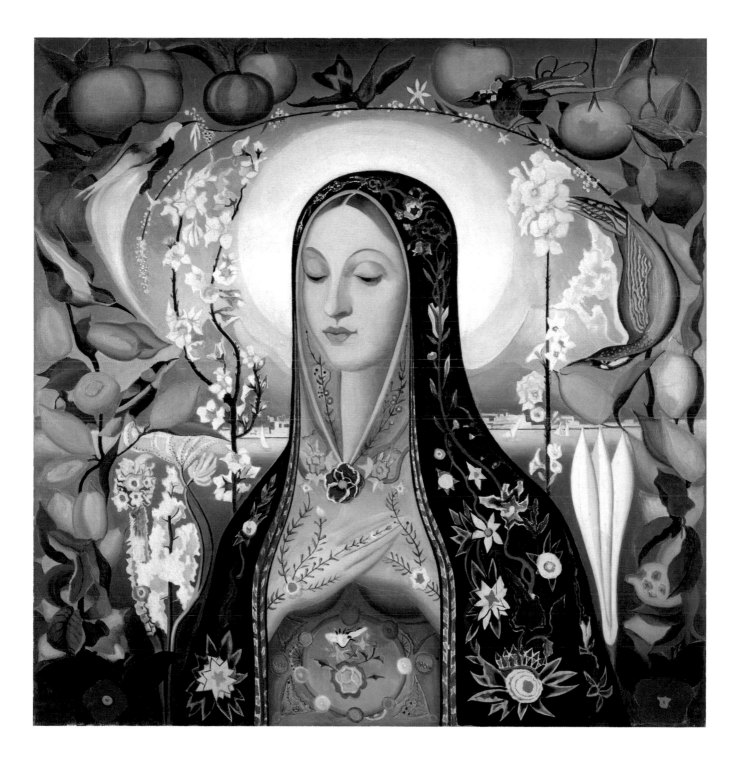

Georgia O'Keeffe (American, 1887–1986)

2 Yellow Leaves (*Yellow Leaves*), 1928
Oil on canvas, 40 x 30⅛ in. (101.6 x 76.5 cm)
Bequest of Georgia O'Keeffe, 87.136.6
© 2011 Georgia O'Keeffe Museum / Artists Rights Society (ARS), New York

Pared down to their essential structure and rendered with subtly modulated colors, the two overlapping leaves in this work take on a grandeur and expressive intensity that characterized the close-up botanical imagery of Georgia O'Keeffe (see also page 41). The leaves are identifiable as American linden (basswood) in their golden, autumnal hue, but O'Keeffe's rendition suggests the general type of the species, not particularized specimens. Simplifying and magnifying the leaves also allowed the artist to conceive of them in broad expanses of pure form and nuanced colors. Her aesthetic approach was indebted to her studies with Arthur Wesley Dow (1857–1922), who emphasized the importance of formal elements—line, color, shape, and tone—over literal imitation. *2 Yellow Leaves* recalls one of Dow's design exercises, in which he asked students to arrange a maple leaf within a seven-inch square in a variety of ways.

O'Keeffe's artistic career began in earnest after the first exhibition of her work (a series of abstract charcoal drawings) at Alfred Stieglitz's (1864–1946) 291 gallery in 1916. He became her mentor, as well as her husband; marrying in 1924, the two had a famously turbulent personal relationship. The Stieglitz circle of progressive artists offered camaraderie and intellectual stimulation, yet O'Keeffe increasingly sought creative inspiration and escape in nature—in places removed from the New York art scene. In the 1920s, annual trips to the Stieglitz family's summer home in Lake George, New York, provided the subject matter for her landscape and botanical paintings, including *2 Yellow Leaves*. KAS

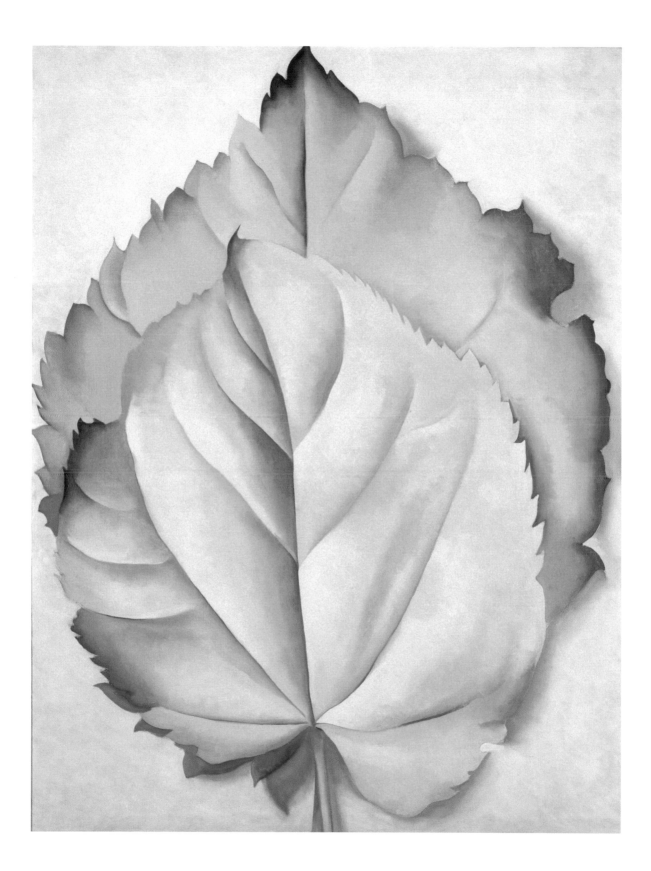

Augustus Vincent Tack (American, 1870–1949)

Canyon, circa 1931
Oil on canvas on cardboard, 46½ x 46 in. (118.1 x 116.8 cm)
Dick S. Ramsay Fund, 59.96

From 1922 to about 1935, in the middle of a successful career painting portraits, religious subjects, and murals, Augustus Vincent Tack created an extraordinary body of nature abstractions inspired by the sublime landscapes of the American West, including Death Valley and the Rocky Mountains. Seeking to break out of his usual representational habits, he projected photographs of these sites onto a canvas, enlarging the motif beyond recognition and then tracing it. *Canyon* is a typical example of this novel approach. Tack filled in the amorphous shapes, whose rust-colored outlines are visible, with heavily impastoed paint in brilliant, nonnaturalistic colors. Although the titles and forms of the paintings in this series still evoke landscapes—here, jagged canyon cliffs dotted with clouds—Tack privileged formalist and expressive concerns over objective representation. His abstracted arrangements epitomize his conviction that "a picture, before being any sort of an anecdote, is in essence a plane surface covered with colors put together in a given order."[1] Tack also wanted to capture his emotional responses to nature's mysteries, as well as the presence of the divine, in these idiosyncratic visions.

Tack's landscape abstractions were commercially unsuccessful: most remained in his New York studio or were collected by Duncan Phillips, his chief patron and the founder of the Phillips Collection, in Washington, DC, America's first museum of modern art. *Canyon* might have been part of an unrealized wall decoration program commissioned by Phillips: the painted gray areas framing the circular landscape composition illusionistically suggest stone architecture. KAS

1. Tack frequently quoted this famous statement of the turn-of-the-century French Symbolist painter Maurice Denis (1870–1943) in his own writings. Augustus Vincent Tack, "A Note on Subjective Painting," *Art and Understanding* 1, no. 2 (Mar. 1930): 240.

Milton Avery (American, 1885–1965)

Artist's Daughter by the Sea, 1943
Oil on canvas, 36 x 42 in. (91.5 x 106.7 cm)
Bequest of Edith and Milton Lowenthal, 1992.11.1
© 2011 Milton Avery Trust / Artists Rights Society (ARS), New York

In this portrait of his only child, March, Milton Avery combined two of his favorite subjects—his daughter and the seashore. Staring directly at the viewer with bright blue eyes, March here sits on the beach with a small collection of seashells at her feet; stylized seagulls hover around her head in an arc formation as if in adoration. The artist united all elements of the composition with a harmonious palette of pinks and lavenders to express his belief in the empathetic bond between humankind and nature. His characteristic use of distortion and broad areas of unmodulated color outlined with dark borders reveals his stylistic debt to Henri Matisse (1869–1954); indeed, critics dubbed Avery the "American Matisse." With its planar flatness and interest in patterns (brushwork and incised lines describe waves and March's hair), the painting has an overall decorative effect. It also conveys a sense of psychological depth, with the eleven-year-old's unselfconscious yet awkward pose hinting at her impending transition from girl to young woman.

Throughout his career, Avery was widely admired for his sophisticated treatment of form and color. Although generally reticent about his work, he aptly summarized his essentializing approach to natural forms: "If I have left out the bridles or any other detail that is supposed to go with horses, trees or the human figure, the only reason for the omissions is that not only are these details unnecessary to the design but their insertion would disorganize space in the canvas already filled by some color or line."[1] KAS

1. "'Modern' Art View Explained by Artists," *Hartford Courant,* Jan. 3, 1931, quoted in Robert Hobbs, *Milton Avery* (New York: Hudson Hills Press, 1990), 51.

Arthur G. Dove (American, 1880–1946)

Flat Surfaces, 1946
Oil on canvas, 27 x 36 in. (68.6 x 91.4 cm)
Dick S. Ramsay Fund, 55.21
© Estate of Arthur G. Dove

Flat Surfaces, Arthur G. Dove's last major canvas, serves as a poignant summation of his longtime aesthetic quest for the "elimination of the non-essential."[1] Basing the composition on the view across Mill Pond from his home in Centerport, Long Island, he drastically distilled the landscape into flat, hard-edged geometric shapes that approach pure abstraction. The horizontal bands of royal blue and orange indicate the water and shoreline, while the trapezoidal shapes in rust, muted green, and gray hues surrounded by black suggest, in the most schematic way, buildings and foliage. Although the overlapping of forms provides a hint of spatial depth, the dominant emphasis is on the two-dimensionality of the picture plane.

Dove began his career as an illustrator for popular magazines, but he decided to change direction after a trip to Paris in 1907–8, when he met his fellow Americans Alfred Maurer (1868–1932) and Max Weber (1881–1961). Though an intimate of the Stieglitz circle, Dove preferred to live and work outside the city in proximity to nature. Considered the first American artist to produce purely nonrepresentational pictures (in 1910), he developed a highly personalized and constantly evolving approach to abstraction, in which he used form and color to express his deep spiritual feelings about the natural world and its vital forces. His works share an affinity with those of Georgia O'Keeffe, who credited Dove as an important influence, and critics frequently compared the two artists. *Flat Surfaces* was made—despite Dove's failing health—during a final campaign of experimentation, when he moved toward even greater degrees of flatness and simplification in his compositions. KAS

1. Arthur G. Dove, "291," *Camera Work*, no. 47 (July 1914): 37.

Milton Avery (American, 1885–1965)

Sunset, 1952
Oil on canvas, 42¼ x 48⅛ in. (107.3 x 122.2 cm)
Gift of Roy R. and Marie S. Neuberger Foundation, Inc., 58.40
© 2011 Milton Avery Trust / Artists Rights Society (ARS), New York

Although his art remained rooted in representation, Milton Avery took an increasingly abstract approach to his landscape subjects in the 1950s. *Sunset* depicts a seascape with waves crashing onto a craggy shore as a radically simplified arrangement of flat, irregular shapes. To enhance this planar quality, the artist used a harmonious color scheme—composed of hues that share the same intensity—and fluid paint application. His thin washes of color are delicately luminous, especially in the glowing peach hues of a sunset reflected on water. In his essentialized landscapes, Avery sought to convey the interconnectedness and universality of the natural world. He particularly loved the ocean and frequently traveled to various shore locales, including Gloucester and Provincetown, in Massachusetts, and the Gaspé Peninsula, in Quebec. In 1952 he summered on the French Riviera (his first trip to Europe), but the generalized topographical features of *Sunset* defy identification.

Although Avery's artistic career had a slow start (he worked in factories and offices to support his family), by the mid-1920s he was painting full-time and prolifically; he often made two works a day until 1949, when poor health reduced his output. By the late 1920s his characteristic style, a blend of representational and abstract elements in planar compositions of lyrical colors, was garnering widespread acclaim. Avery's works also had a profound impact on the younger generation of Abstract Expressionist color-field painters—including Mark Rothko (1903–1970), Adolph Gottlieb (1903–1974), and Barnett Newman (1905–1970), all of whom knew Avery personally (fig. 10). KAS

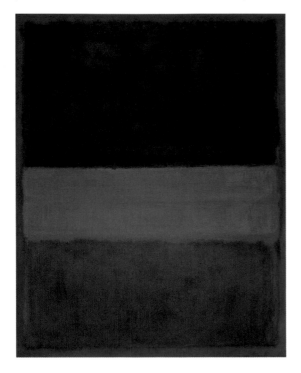

FIG. 10. Mark Rothko (American, born Russia, 1903–1970). *No. 61 (Rust and Blue)*, 1953. Oil on canvas, 115¼ x 92¼ in. (292.7 x 234.3 cm). Museum of Contemporary Art, Los Angeles, The Panza Collection, 84.9. © 1998 Kate Rothko Prizel and Christopher Rothko / Artists Rights Society (ARS), New York

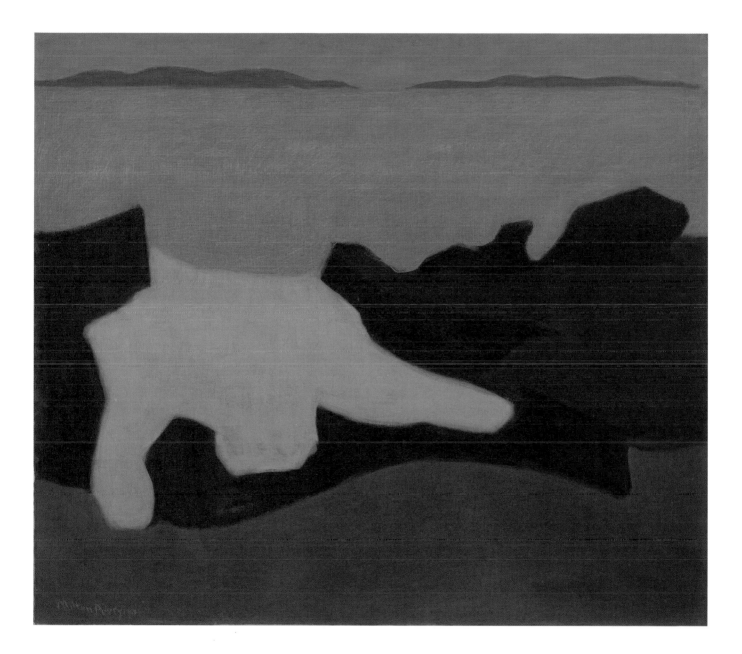

Loren MacIver (American, 1909–1998)

Fishers Island, circa 1952
Oil on Masonite, 44⅛ x 57⅛ in. (112.1 x 145.1 cm)
Gift of the Roy R. and Marie S. Neuberger Foundation, 57.43
© Estate of Loren MacIver, Courtesy of Alexandre Gallery, New York

In 1946 Loren MacIver wrote of her painting process: "Quite simple things can lead to discovery. This is what I would like to do with painting: starting with simple things, to lead the eye by various manipulations of colors, objects, and tensions toward a transformation and reward."[1] In this work, the artist transformed an ordinary seascape of three rocks along the shore of Fishers Island, off the Connecticut coast, into an image of great intimacy and poetic beauty. The rocks seem to float against a flattened backdrop of horizontal bands denoting the sky, water, frothy surf, and pebbled beach. MacIver created colors of rich depth and luminosity through thin glazes of paint; she also evoked the texture and shape of the natural forms with directional brushstrokes and daubs of pure color (as in the white highlights for water drops that ring the rocks).

With its combined effects of realism and abstraction, materiality and spirituality, *Fishers Island* typifies MacIver's oeuvre. Largely self-taught and independent of any particular school or style, the New York artist sought to endow everyday objects and landscapes with inner life—an approach fostered by her close association with poets such as E. E. Cummings, Marianne Moore, and Lloyd Frankenberg, her husband. MacIver's lyrical paintings were highly admired by the art world and the public: she exhibited widely and was the first woman to have a work enter the collection of the Museum of Modern Art. KAS

1. Loren MacIver, artist's statement, in Dorothy C. Miller, ed., *Fourteen Americans* (New York: Museum of Modern Art, 1946), 28.

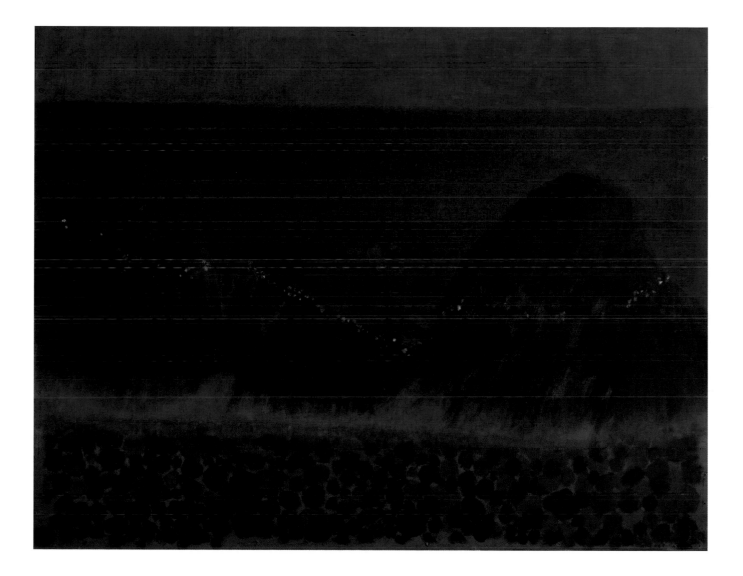

Georgia O'Keeffe (American, 1887–1986)

Green Yellow and Orange, 1960
Oil on canvas, 40 x 30 in. (101.6 x 76.2 cm)
Bequest of Georgia O'Keeffe, 87.136.3
© 2011 Georgia O'Keeffe Museum / Artists Rights Society (ARS), New York

As its title suggests, this work seems to take as its subject matter color itself: an undulating ribbonlike green line against a field of rich yellow and orange. Georgia O'Keeffe applied the paint in carefully calibrated hues and tones to suggest variations in depth and form across the flat surface of the canvas. Despite its purely abstract appearance, this painting does reference the natural world—specifically, the road around O'Keeffe's Abiquiu home, north of Santa Fe, as seen from the window of an airplane.

Beginning in 1929, the artist made annual trips to New Mexico, settling there permanently in 1949. She fell in love with the austere beauty of the Southwest and incorporated motifs she encountered—geological formations, desert vegetation, desiccated animal bones, adobe structures—into her artistic repertoire. Flying offered a new vantage point on this familiar terrain. (Despite her popular reputation as a desert recluse, O'Keeffe in fact traveled extensively around the globe from the 1950s to the 1970s.) Her series of abstract aerial landscape views—including this work—constituted one of the final groups of paintings she made before failing health and eyesight reduced her productivity. In many ways, *Green Yellow and Orange* recasts issues that concerned her over the course of her long career, such as finding the essential forms of nature through abstraction, expressing her emotional responses to a motif, and providing unexpected perspectives on familiar things (as in, for instance, her famous magnified flower pictures). KAS

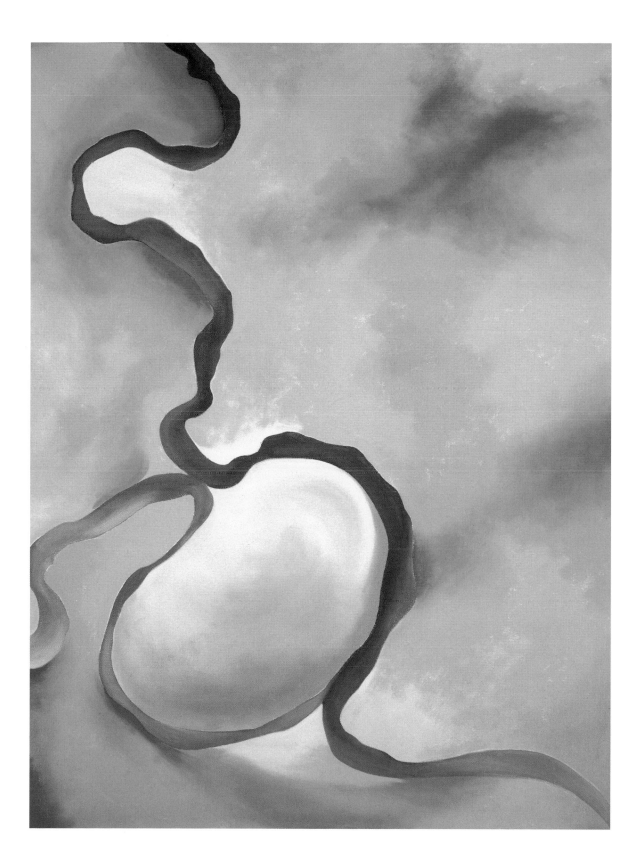

MODERN
STRUCTURES

The physical transformation of the landscape through urbanization and industrialization was one of the most conspicuous changes in modern America. Construction occurred at an unprecedented scale and pace as cities and towns built the infrastructure necessary to accommodate growing populations, commercial businesses, and industrial production and its machinery. Extensive transportation networks also were developed to move goods and people around the country and the globe. Office towers and apartments, factories and warehouses, roads and rail lines, bridges and tunnels, docks and ports—these structures were tangible, visible testaments to the nation's economic vitality. The skyscraper emerged in the twentieth century as the primary icon of the modern metropolis—and of New York City, in particular, with its world-famous skyline (fig. 11). As feats of engineering, these soaring buildings embodied the nation's technological mastery of nature and its aspirations for continuous progress. Skyscrapers also gave a new vertical height to the city and altered the ways in which humans experienced urban spaces.

The diverse artists featured in this section found thematic and aesthetic inspiration in the transformed American landscape, which they represented in a range of styles. Some realistically documented the appearance of the modern built environment and the dynamic process of change in which the natural and synthetic, old and new, were juxtaposed. Precisionist artists developed a style that combined their interest in abstraction with the streamlined forms and gridded geometries of urban and industrial architecture. Still other artists responded to the sensory experience of city life—the constant barrage of visual stimuli and the fleeting, fragmentary images glimpsed amid the hustle and bustle. These pictures tend to be celebratory, rarely addressing the exploitation of laborers and natural resources, the displacement of communities, or other negative effects of modernization.

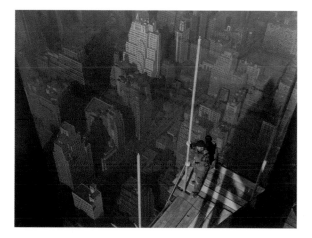

FIG. 11. Lewis Wickes Hine (American, 1874–1940). *Raising the Mast, Empire State Building*, 1931. Gelatin silver print, 10¾ x 13¾ in. (34.9 x 27.3 cm). Brooklyn Museum, Gift of Walter and Naomi Rosenblum, 84.237.10

George Wesley Bellows (American, 1882–1925)

The Sand Cart, 1917
Oil on canvas, 30¼ x 44⅟₁₆ in. (76.8 x 111.9 cm)
John B. Woodward Memorial Fund, 24.85

On a beach used by local fishermen (as evidenced by the boats and fish in the foreground and the rowboat at far left), a group of men gathers sand for use in making concrete for building construction. This painting combines two main themes in George Wesley Bellows's work: urban laborers and industrial development; and heroic fishermen and their daily struggle against the natural elements. *The Sand Cart* was executed during the summer of 1917, when Bellows made an extended trip to Carmel, California, to complete a portrait commission. In his free time, he explored the surrounding countryside by automobile, visiting Point Lobos and other locales. In this canvas, Bellows focused not on the dramatic scenery of the Pacific coast but, rather, on human efforts to control and shape the natural environment.

When the painting was first exhibited, critics praised its epic portrayal of laboring men and horses and its grasp of the universal and timeless quality of work. In an era in which the image of the heroic laborer was central to notions of industrial progress, the painting celebrated the human toil behind the building of America's cities, roads, skyscrapers, subways, and railroads.

Bellows was best known for his association with the Ashcan School and for his vigorously brushed and thickly painted views of modern industrial landscapes, including New York City's active waterfront, construction sites, bridges, and railroads. During summers away from the city, he also specialized in landscapes and portraits, and later in his career he became a skilled lithographer. The image of *The Sand Cart* appears to have retained some interest for Bellows, who translated it into a lithograph, *The Sand Team*, two years later. MS

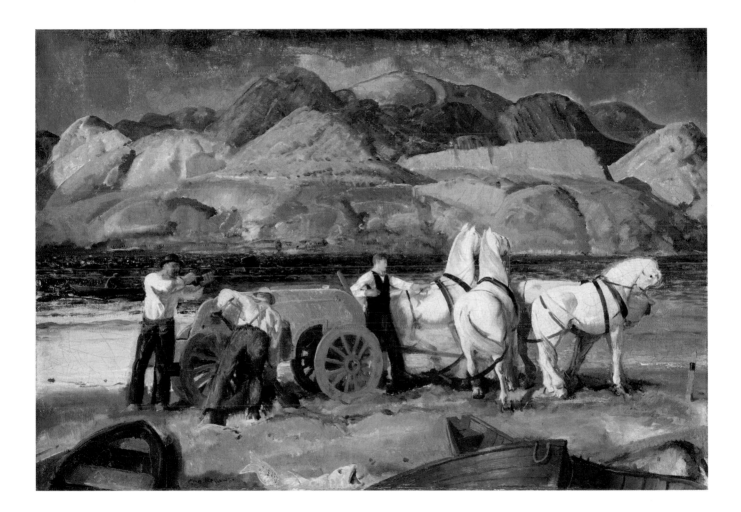

Isabel Lydia Whitney (American, 1884–1962)

The Emerald Tower, 1927–28
Oil on canvas, 24 x 18 in. (61 x 45.7 cm)
Gift of Mrs. James H. Hayes, 54.18

The Emerald Tower depicts a nighttime view of Columbia Heights, a premier residential street of Brooklyn, at the point where it descends sharply to the Fulton Ferry landing. Period photographs of the street often focus on the majestic Brooklyn Bridge towering over the small buildings. In this view,

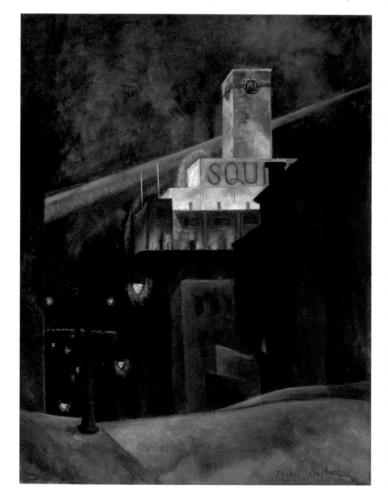

however, the iconic bridge is relegated to the far distance, and the painting is dominated instead by the new Squibb building, whose garish tricolor glow seems to reduce the stately old streetlights to tiny fireflies. Part of the manufacturing plant of E. R. Squibb & Sons Pharmaceuticals, the Squibb Tower was one of the earliest buildings in the city to be illuminated by indirect lighting. A bright blue ray of light cutting across the background suggests a rotating searchlight beam.

This work belongs to a series that the decorative muralist and illustrator Isabel Lydia Whitney painted about 1927 of her changing Brooklyn Heights neighborhood. Exhibited in 1928, the series was praised for its honest depiction of the American scene and "the poignancy of transition," which was described by the art critic Helen Appleton Read: "The spacious brownstone mansions, facing the harbor, are huddled into anachronistic groups as their neighbours give way to giant apartment-houses."[1] With this series, Whitney was compared to Reginald Marsh (1898–1954), Glenn O. Coleman (1884–1932), Charles Burchfield (1893–1967), and others known for their frank, unpretentious depictions of the everyday subject matter of American life. MS

1. Helen Appleton Read, "Contemporary Art: The American Scene Receives a New Interpretation," *Vogue,* undated clipping [circa 1928–29], and Helen Appleton Read, "Brooklyn Heights in Oil," *Brooklyn Daily Eagle,* Dec. 2, 1928; clipping scrapbook, Isabel Lydia Whitney Papers, 1832–1973, microfilm, Archives of American Art, Smithsonian Institution, roll 3615, frame numbers illegible.

Isabel Lydia Whitney (American, 1884–1962)

The Blue Peter, 1927–28
Oil on canvas, 18 x 23¹⁵⁄₁₆ in. (45.7 x 60.8 cm)
Gift of Mrs. James H. Hayes, 54.20

In this busy waterfront scene, a well-dressed woman watches over her two children as they stand mesmerized by the harbor activity. The figures themselves are relatively inconspicuous: what catches the eye, instead, in *The Blue Peter* is the flattened space and the mosaic of abstract shapes, patterns, and lines, in which glimpses of windows, masts, smokestacks, and rigging are sharply juxtaposed with the vivid blue sky and the black-and-white-striped barricades. The painting's title refers to the nautical flag, blue with a central white rectangle, seen at top center. Representing the letter *P* in the International Code of Signals, the flag also indicates that a ship is about to sail and that all persons should report on board.

 The Blue Peter is one of a dozen or so works that Isabel Lydia Whitney painted of her Brooklyn neighborhood, whose high bluffs overlooked the East River and New York Harbor. These small canvases offered a welcome break from her larger and more strenuous decorative fresco commissions for private houses and clubs.

 The daughter of a wealthy silk manufacturer, Whitney grew up in Brooklyn Heights, a prosperous and elegant residential neighborhood developed in the mid-nineteenth century. By the late 1920s many of the district's old families were worried about the imminent decay of their once-genteel community as many stately mansions were turned into boardinghouses or demolished to make way for apartment towers. Reflecting these concerns, Whitney recorded in her paintings both the area's beloved old landmarks and signs of the intrusion of waterfront commerce and manufacturing. MS

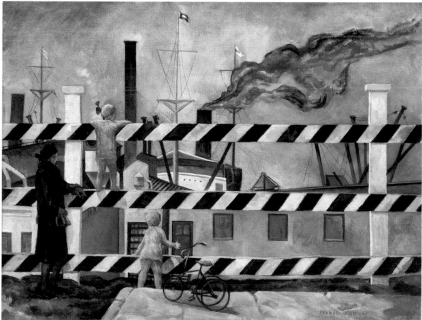

Glenn O. Coleman (American, 1884–1932)

Gloucester Harbor, circa 1930
Oil on canvas, 34⅛ x 25⅛ in. (86.6 x 63.8 cm)
Gift of Mr. and Mrs. Alan H. Temple, 58.81

Glenn O. Coleman's *Gloucester Harbor* is a picturesque harbor scene viewed through the posts of a traditional square frame hoist, a wooden framework used to unload vessels at the wharves. Through this "window" we see a sharply contracted vista of Rocky Neck, with the many fishing boats, coils of ropes, spars, and masts near the wharf juxtaposed with the docks and houses across the harbor.

Gloucester Harbor is one of a number of Coleman's paintings depicting Massachusetts fishing villages. He most likely visited the area with Stuart Davis (1892–1964), one of his closest friends, who maintained a summer studio in Gloucester starting in 1926. Both were fascinated by the region's historic fishing industry and painted numerous harbor and dockside views, traditional artistic subjects that they appropriated for their modernist experimentations. Eliminating people from these scenes, they were able to bypass the narrative or metaphorical aspects of maritime life and to treat the space—and the structures and objects within it—primarily as design elements in an updated modernist style.

In the late 1920s, Coleman often used windows, doorways, or other framing devices to juxtapose near and far, interior and exterior. *Gloucester Harbor* thus compresses the space between a close-up, bird's-eye view of the water from the edge of a dock and a panoramic prospect of the distant hill and its densely clustered buildings. Coleman's works blend realism and abstraction, and experiment with flattened space, recalling Paul Cézanne's (1839–1906) innovative landscapes in their use of multiple perspectives. The compositional framing device also appears in several of Davis's Gloucester dock scenes from the 1920s, suggesting a fertile creative exchange between the two friends, although Davis's canvases are decidedly more abstract and geometric than Coleman's. MS

Luigi Lucioni (American, born Italy, 1900–1988)

A Barre Granite Shed, 1931
Oil on canvas, 19⅛ x 14¹⁵⁄₁₆ in. (48.6 x 38 cm)
Gift of Mrs. Horace Havemeyer, 42.199

Painted in hyperrealistic detail, *A Barre Granite Shed* depicts the Jones Brothers Manufacturing plant, located on the Winooski River near Barre, Vermont. Luigi Lucioni painstakingly rendered even small details of the plant (built in 1895, during the boom period of Barre's granite industry), such as the bricks, dam, cranes, and smokestacks. He also captured the precise geometric alignments of the long sheds, in which quarried granite blocks were transformed into building materials and stone monuments.

Lucioni's quiet landscape suggests the harmonious coexistence of agriculture and industry. Though depicting a rural setting, the work is similar in approach to the Precisionist views extolling American industry by Charles Sheeler (1883–1965) and others, and it conveys a sense of order, prosperity, and progress even at the onset of the Great Depression. Despite the prominence of stone quarries and factories in New England, Lucioni painted only a few such industrial scenes. Instead, he made a successful career as a painter of interior still lifes and portraits during winters in New York City and focused on Vermont's rolling hills, pastures, barns, and trees every summer.

Trained as an Impressionist landscape painter, Lucioni changed his style dramatically after several trips to his native Italy in the late 1920s. There he was influenced by the clear light of the Italian landscape and the crisply delineated style of the Renaissance masters Piero della Francesca (1415–1492) and Andrea Mantegna (circa 1431–1506; see fig. 9). The Vermont landscape became his signature subject matter after a visit in 1930. "It was like seeing the mountainsides of my birthplace," he later recalled. "I was reborn in this majestic setting and I fell in love with Vermont."[1] MS

1. Luigi Lucioni, quoted in Richard H. Saunders, *Pastoral Vermont: The Paintings and Etchings of Luigi Lucioni* (Middlebury, VT: Middlebury College Museum of Art, 2009), 18.

Glenn O. Coleman (American, 1884–1932)

Bridge Tower, 1929
Oil on canvas, 30⅛ x 25⅛ in. (76.5 x 63.8 cm)
Gift of Charles Simon, 60.35

The Brooklyn Bridge is one of the oldest surviving suspension bridges in the United States and has been an enduring symbol of New York City and American technological leadership since its completion in 1883. Glenn O. Coleman was only one of countless artists to paint the bridge against the backdrop of the rapidly growing city.

Recording the unprecedented building boom taking place in the Wall Street district in the 1920s, *Bridge Tower* focuses on the built landscape and the competing forms of the numerous structures along the Manhattan skyline. Reflecting recent modernist innovations, Coleman's view simplifies these many elements to their fundamental shapes. Strong verticals (the massive tower of the bridge, skyscrapers resembling stacked blocks, and the rows of red-brick tenements and warehouses) play against horizontals and diagonals (the massive gunboat gliding up the East River, the piers jutting out into the water, and the steel bridge cables and roadway). The unnatural colors, demarcating the four quadrants of the picture, may reflect the influence of Coleman's close friend Stuart Davis, whose highly abstracted city scenes of the late 1920s reduced the urban landscape to flat planes and blocks of color (see pages 96, 97).

Coleman's early paintings depict New York's streets and people—most often in immigrant neighborhoods—reflecting his close association with the Ashcan circle of Robert Henri (1865–1929). In the late 1920s, however, Coleman's interest shifted to more experimental, partially abstracted landscapes—including distant harbor views such as this one. MS

Francis Criss (American, born England, 1901–1973)

City Landscape, 1934
Oil on canvas, 28⅞ x 36⅞ in. (73.3 x 93.7 cm)
Courtesy of the Fine Arts Program, US General Services Administration, L34.118

City Landscape was painted in 1934 for the Federal Art Project, a New Deal program of the Works Progress Administration (WPA) that employed out-of-work artists to document the American scene. This view of the intersection of New York's Eighth and Greenwich Avenues and Fourteenth Street records the dynamic urban landscape, in which the old is continually superseded by the new (fig. 12). The old buildings representing different architectural styles—the simple four-story pink facade, the classicized marble New York County National Bank (completed in 1907), and the domed Beaux-Arts New York Savings Bank (completed in 1897)—jostle for space in

FIG. 12. Intersection of Eighth and Greenwich Avenues and Fourteenth Street, 2011. Photo: Sally Minker

the shadow of the massive new Port Authority Commerce Building under construction in the background. This shipping and transportation hub was described in 1932 as "one of the most stupendous achievements of the age" and "one of the very largest buildings in the world."[1]

The painting's generic title, the For Sale and For Rent signs, and the word *Trust* inscribed above the bank door suggest an ironic commentary on the deflated 1930s economy. In contrast, economic growth and prosperity are embodied by the new building and the row of V8 automobiles, Ford's latest model, also advertised on the billboard at far right. Produced from 1932 to 1934, the V8 was the first low-priced, mass-marketed car with a high-performance engine—and the preferred getaway car for the infamous bank robbers Bonnie and Clyde.

In the 1920s and 1930s Francis Criss was primarily known for his Precisionist cityscapes, such as this one, which reduced factories and skyscrapers, street signs, lampposts, and elevated subway tracks to colorful arrangements of geometric shapes and lines. After the Depression, he designed posters for the US Office of War Information and worked mainly as an art teacher, muralist, and commercial artist. MS

1. W. Parker Chase, *New York: The Wonder City, 1932* (New York: Wonder City Publishing Company, 1932; reprint, New York: New York Bound, 1983), 200. In 2010 the building was purchased by Google for use as commercial office space. The empty lot at the lower right of Criss's composition is now occupied by high-rise condominiums.

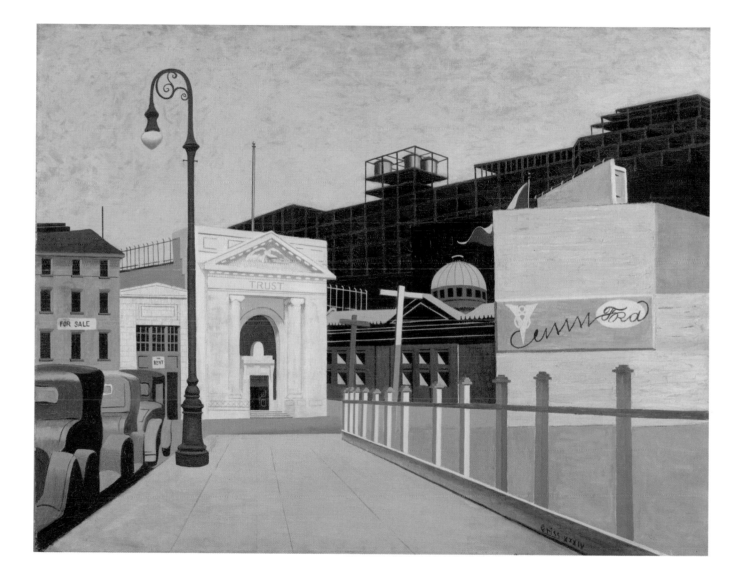

Herzl Emanuel (American, 1914–2002)

View of Lower Manhattan, modeled 1937; cast 1990
Bronze, 8¼ x 23¹³⁄₁₆ x 1¼ in. (21 x 60.5 x 3.2 cm)
Purchase gift of The Richard Florsheim Art Fund, 1996.186

After spending five years in Europe as an art student, Herzl Emanuel returned to the United States in 1936 and found a studio in Brooklyn with a majestic view of the Brooklyn Bridge. *View of Lower Manhattan* beautifully encapsulates the multiplicity of fragmentary elements he saw in the urban infrastructure, shown as if they were fleeting glimpses viewed from the subway train speeding across the nearby Manhattan Bridge—distant skyscrapers, brick walls and archways, cobblestone streets, decorative architectural elements, letters and signs, steps and streetcar tracks, wooden planking, and natural elements such as clouds and waves. A former student of the Cubist artists Ossip Zadkine (1890–1967) and Fernand Léger (1881–1955) and an inaugural member of American Abstract Artists (established in 1936), Emanuel found the Cubist idiom perfectly suited to this vision of the dynamic New York waterfront. As he recalled, "This assortment of visual elements was extremely rich, almost overwhelming [and] the challenge was to organize all this seductive material into a coherent structure."[1] He worked through this challenge in numerous preparatory drawings (fig. 13) before completing the model for this sculptural relief.

 View of Lower Manhattan is decidedly different from most of Emanuel's sculptural work, which generally focuses on the human figure, but its subject matter—including the iconic Brooklyn Bridge—was perfect for the Federal Art Project, under whose auspices he created this piece. Although much of his WPA output was destroyed when the project came to an end, Emanuel managed to save the original plaster for *View of Lower Manhattan*. The model remained in his studio for more than fifty years before being cast in bronze in an edition of six, of which this is the fifth. MS

1. Herzl Emanuel, artist's statement, circa 1996, Curatorial file (1996.186), American Art, Brooklyn Museum.

FIG. 13. Herzl Emanuel (American, 1914–2002). *New York Skyline*, 1937. Pencil on paper, 7½ x 9⅝ in. (19 x 24.5 cm). Smithsonian American Art Museum, Washington, DC, Gift of Patricia and Phillip Frost, 1986.92.21. Photo: Smithsonian American Art Museum / Art Resource, NY

Stuart Davis (American, 1892–1964)

Landscape with Clay Pipe, 1941
Oil on canvas, 12 x 18 in. (30.5 x 45.7 cm)
Bequest of Edith and Milton Lowenthal, 1992.11.4
© Estate of Stuart Davis / Licensed by VAGA, New York, NY

With the artist's characteristic bold, nonnaturalistic colors and hard-edged forms, *Landscape with Clay Pipe* creates a conceptual landscape evoking the world of male leisure—motoring, boating, smoking, and gambling. This densely packed composition contains a profusion of objects, graphics, and abstract elements (shapes, dots, and lines) rendered in simplified, flattened planes. Recognizable images include a pipe, gas pump, cigar, matchbook, playing card, barber pole, and horseshoe. Stuart Davis recycled many of these motifs from a 1932 mural he had created for the men's lounge in Radio City Music Hall in New York. In this canvas, one finds a few references to place—a boat on the water, a building (possibly a bar)—but the dominant impression is of the fast pace and materialism of modern American life. The artist enhanced the picture's visual intensity by painting a white border around the colorful central register.

Throughout his long career, Davis drew inspiration from the contemporary American experience, particularly its consumer products and advertising, technological advances, jazz music, and urban environments. A politically active and polemical artist, he worked in the Realist style of his teacher Robert Henri, leader of the Ashcan School, until the 1913 Armory Show, which convinced Davis to experiment with modernist abstraction. By the 1920s, he had developed his distinctive artistic vocabulary of sharply defined, intersecting planes derived from Synthetic Cubism. He was also deeply engaged in theoretical concerns and kept voluminous journals of his ideas. His paintings of the early 1940s, including *Landscape with Clay Pipe,* articulate his newly developed "color space theory," in which juxtapositions of different color values suggest spatial depth based on how certain hues appear to advance or recede. KAS

Stuart Davis (American, 1892–1964)

Pad No. 4, 1947
Oil on canvas, 14 x 18 in. (35.6 x 45.7 cm)
Bequest of Edith and Milton Lowenthal, 1992.11.5
© Estate of Stuart Davis / Licensed by VAGA, New York, NY

In this painting, Stuart Davis created a complex tapestry of geometric shapes, squiggles, and lines in brilliant, unmodulated colors. He further enlivened this abstract design through his thick paint application, using brushstrokes to define distinct textures and crisp edges for the different forms. Like his earlier painting *Landscape with Clay Pipe* (opposite), *Pad No. 4* captures the dynamic energy and sensory overload characteristic of modern American life, but with a greater degree of abstraction. As one critic observed, "[Davis's] art relates to jazz, to movie marquees, to the streamlined decor and brutal colors of gasoline stations, to the glare of neon lights . . . to the big bright words that are shouted at us from bill-boards."[1]

Pad No. 4 is one of a series of four related pictures that Davis made between 1945 and 1951 while working on *The Mellow Pad* (Brooklyn Museum), one of his most complex compositions. Each of these works contains the word *pad* in the composition: here, it appears sideways in green at the upper left (and a *4* is in white at the lower right). This title reveals the artist's fondness for wordplay: *pad* refers both to an artist's sketchbook and to the slang term for "home" from the hip lingo of jazz. A lifelong aficionado of jazz, Davis (as well as his critics) regularly drew analogies between the visual patterns of his pictures and the syncopated rhythms of this modern form of American music.

One of the most progressive American modernists of the first half of the twentieth century, Davis became highly regarded for his unique aesthetic, which combined the theoretical concerns of avant-garde European art with themes rooted in the American experience. His interest in abstraction and allover decoration made him an important precursor to the Abstract Expressionists of midcentury, and his embrace of popular and consumer culture anticipated Pop art of the 1960s. KAS

1. Elaine de Kooning, "Stuart Davis: True to Life," *Art News* 56 (Apr. 1957): 42.

George Copeland Ault (American, 1891–1948)

Manhattan Mosaic, 1947
Oil on canvas, 31⅞ x 18 in. (81 x 45.7 cm)
Dick S. Ramsay Fund, 66.127

The visual impact of the New York skyscraper—the interlocking patterns of its windows, setback facades, flat rooftops, water tanks, and spires, and the dramatic contrasts between light and dark shadows—fascinated countless modernists. In *Manhattan Mosaic,* George Copeland Ault's narrow view of urban rooftops transforms the buildings into an abstract mosaic in which architectural elements are considered purely as an aesthetic arrangement of planes and angles.

In 1937, seeking solitude, Ault moved to Woodstock, New York, and began producing moody rural landscapes with Surrealist undertones. On occasional visits to Manhattan, however, he painted city views such as this one from his Midtown hotel. *Manhattan Mosaic* returns to one of the artist's earlier and most successful themes—the New York skyline—perhaps recalling the happier times of the 1920s. During that period, Ault had created his most abstract cityscapes while working in a sixth-floor studio in a lower Manhattan perfume factory. He exhibited frequently and, along with Niles Spencer (1893–1952), Georgia O'Keeffe (1887–1986), Charles Sheeler, and others, became known for his depopulated Precisionist urban scenes, which emphasized the rich visual geometries of the modern city. In *Manhattan Mosaic,* the play of overlapping shapes, the harmonious blend of brown tonalities, and the deep shadows created by strong light all exemplify the style, which was popular in the 1920s and 1930s. This work was painted during the last year of Ault's life, when his finances were shaky and he was in a depressed mental state. The composition's tightly enclosed rooftop space reveals only a small view of sky in the distance, suggesting a feeling of claustrophobia and anxiety that is not found in the artist's earlier works. MS

ENGAGING
CHARACTERS

By 1920 the majority of Americans lived in cities—a fact that marked the culmination of the nation's transformation over the preceding century from a rural, agrarian society to an urban, industrialized one. (This demographic concentration would persist until the rapid rise of suburbs in the post–World War II era.) Both domestic migration and foreign immigration had sparked the dramatic growth in urban populations. Cities teemed with inhabitants from diverse ethnic, economic, religious, and cultural backgrounds. Social interactions were often marked by anxiety as people conducted business or coexisted in close physical proximity with complete strangers. Although modern life and leisure pursuits offered new opportunities for socializing, many city dwellers felt alienation and isolation within the anonymous throngs.

Various factors also altered the dynamics between the sexes, especially in the urban environment. Unprecedented numbers of women entered the workforce and earned their own wages; in addition, they gained improved access to higher education and, with the passage of the Nineteenth Amendment in 1920, the right to vote. As Americans became familiar with Sigmund Freud's theories during the first half of the twentieth century, they developed more liberated ideas about human sexuality, although traditional mores and gender roles remained influential.

The artists represented in this section embraced the human spectacle of the modern city as their subject matter. Generally adopting a realist style, they created insightful social commentaries based on close observation of people and their interactions. The characters depicted here represent a broad spectrum of classes and types found in the urban milieu—the savvy businessman, the independent New Woman, the down-on-his-luck homeless man, and others. The works of art in which they appear capture both the pleasures and pitfalls of modern society.

Max Weber (American, born Russia, 1881–1961)

Abraham Walkowitz, 1907
Oil on canvas, 25¼ x 20¼ in. (64.1 x 51.4 cm)
Gift of Abraham Walkowitz, 44.65

In this sensitive portrait by his close friend Max Weber, Abraham Walkowitz (1880–1965) appears as a confident young art student during his bohemian Paris years. The painting is an overt homage to Paul Cézanne (1839–1906), who was a major inspiration for many American modernists. The three-quarter profile pose, subdued palette,

FIG. 14. Paul Cézanne (French, 1839–1906). *Self-Portrait with Black Felt Hat*, 1879–82. Oil on canvas, 24¼ x 20 in. (61.5 x 50.5 cm). Kunstmuseum Bern, Switzerland, G1674

and patchy brushstrokes imitate the earlier artist's unique painting style, particularly as seen in the numerous self-portraits that Cézanne painted throughout his career (fig. 14).

Weber and Walkowitz, both Russian-born New Yorkers, first encountered Cézanne's works at the Paris Salon d'Automne in 1906, shortly after the French painter's death. Weber later wrote, "As soon as I saw them they gripped me at once and forever."[1] Thereafter, the two friends actively sought out and studied Cézanne's art at Parisian galleries, and Weber purchased a set of photographic reproductions of the French master's paintings that likely served as models for his own canvases.

After an extended trip through Italy with Weber, Walkowitz went home to New York in late 1907. When Weber also returned the following year, the two resumed their friendship, sharing a studio and becoming closely associated with Alfred Stieglitz's (1864–1946) seminal 291 gallery, which exhibited the newest European and American modernist art. Weber severed ties with the domineering Stieglitz in 1911, however, and soon afterward he also broke with Walkowitz, who remained in the dealer's inner circle. Walkowitz nevertheless kept this portrait as a reminder of this friendship with Weber and the social camaraderie of their student years, donating it to the Brooklyn Museum in 1944. MS

1. Max Weber, quoted in Lloyd Goodrich, *Max Weber: A Retrospective Exhibition* (New York: Whitney Museum of American Art, 1949), 11.

Guy Pène du Bois (American, 1884–1958)

The Confidence Man, 1919
Oil on plywood panel, 20 x 15 in. (50.8 x 38.1 cm)
Gift of Chester Dale, 63.148.3

In *The Confidence Man,* a man and woman in evening attire stand closely together, appearing to share secrets. The title suggests that the man is not to be trusted. Is he a swindler? Is she a victim or a collaborator? Are they conducting a clandestine extramarital affair? Executed with the dark palette and thick paint characteristic of the Ashcan School, with which Guy Pène du Bois was associated as a young artist, *The Confidence Man* suggests a menacing view of modern urban society, in which people are thrown into regular contact with strangers but remain unable to read or trust each other's motives.

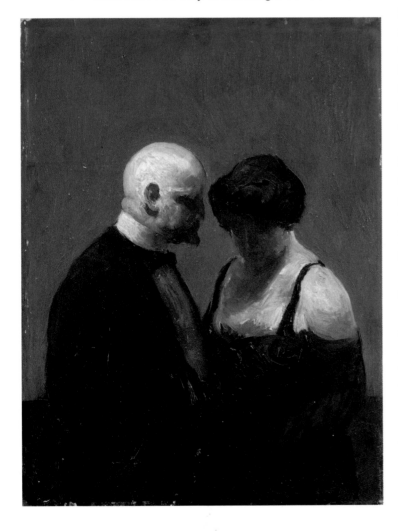

Pène du Bois's fascination with human behavior began in art school. Greatly influenced by his teacher Robert Henri's (1865–1929) philosophy concerning the interconnectedness of art and life, Pène du Bois and his fellow students, including Edward Hopper (1882–1967), Rockwell Kent (1882–1971), and George Wesley Bellows (1882–1925), frequented cafés and other public places, making sketches of the people they observed.

While working for the *New York American* as a beat reporter, a music and theater critic, and, after 1908, an art critic, Pène du Bois traveled to all sides of town and was exposed to people from all walks of life. With a critic's distance, he observed and interpreted conversations and social conventions of modern nightlife. In his free time he painted. "I did it for fun," he wrote later, "and as a means of expressing things not so easily said in print."[1] MS

1. Guy Pène du Bois, *Artists Say the Silliest Things* (New York: American Artists Group, 1940), 195.

Guy Pène du Bois (American, 1884–1958)

Evening, 1929
Oil on canvas, 21¾ x 18³⁄₁₆ in. (55.2 x 46 cm)
Gift of Daniel and Rita Fraad, Jr., 65.204.2
© Estate of Yvonne Pène du Bois McKenney and Graham Gallery, New York

A depiction of a young couple in conversation on a night out, *Evening* evokes the high-spirited attitude and hedonism of the Jazz Age on the eve of the Great Depression. Flappers were often viewed as giddy and attractive young women who flouted conventional behavior, wearing short hair and short skirts, dancing suggestively at jazz clubs, smoking cigarettes through long holders, and dating

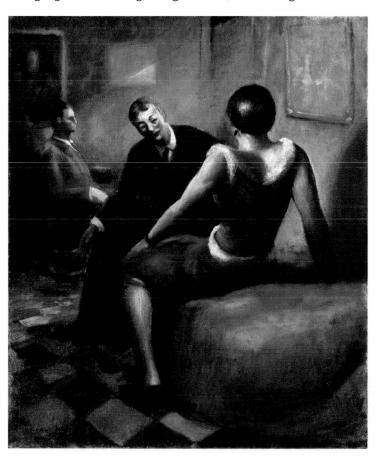

casually, almost recklessly. While the woman's face is not visible here, the view from behind shows her modern bob and her bold, open pose, indicating that she initiated the interaction and is actively encouraging her partner's attention. The seated figure in the back stands in as a chaperone of sorts, making the encounter appear less provocative.

After twenty years as a reporter, writer, art critic, and part-time artist, Guy Pène du Bois quit his day job in 1924 and took his family to Paris for an extended stay. There he focused solely on his art career, painting numerous depictions of people attending parties and social events—subjects that continued to interest him after his return to America five years later.

Pène du Bois's satirical depictions of high society often focused on intimate conversations between men and women or other pairs. He frequently painted stiff figures with masklike faces, suggesting social alienation beneath the glitter and gloss of the party scene. Despite his figures' physical closeness, their faces are inscrutable and the nature of their interactions is ambiguous. MS

Mahonri M. Young (American, 1877–1957)

Right to the Jaw, 1926
Bronze, 14½ x 20½ x 9 in. (36.8 x 52.1 x 22.9 cm)
Robert B. Woodward Memorial Fund, 28.422

Right to the Jaw, a realistic portrayal of two boxers in motion, is Mahonri M. Young's most famous work. Starting in 1926, Young produced a highly successful series of tabletop genre sculptures that vividly captured the action of the boxing ring. With colorful titles like *Groggy, The Knockdown, Two Bantams, On the Button,* and *Da Winner,* these works were praised for authentically capturing the beauty of the athletic human body.

The great popularity of Young's boxers grew out of Americans' intense infatuation with the sport in the 1920s. Young may have become interested in boxing through his brother Wally, a professional sports reporter in San Francisco, but he also knew Jack Dempsey, who held the world heavyweight title from 1919 to 1926. (Both Young and Dempsey were Utah natives.) In the 1920s—"the Golden Age of Sports"—the exploits of celebrity athletes, including the baseball player Babe Ruth, the golfer Bobby Jones, the tennis player Helen Wills, and even the horse Man o' War, were avidly followed in newspapers and mass media by millions of fans. Some athletes, such as the Olympic medalist Johnny Weissmuller, even became movie stars.

Despite their overwhelming success, Young's boxing subjects were limited to the late 1920s. A prolific painter, watercolorist, etcher, and sculptor of public monuments, Young was also noted for his naturalistically modeled bronze figurines of coal carriers, coal shovelers, canal boatmen, riggers, drillers, blacksmiths, stevedores, and other manual laborers. The powerful sense of realism in these works and their focus on the daily life of the working class were also characteristic of works by the Ashcan School and by the sculptors Constantin Meunier (1831–1905) and Abastenia St. Leger Eberle (1878–1942). MS

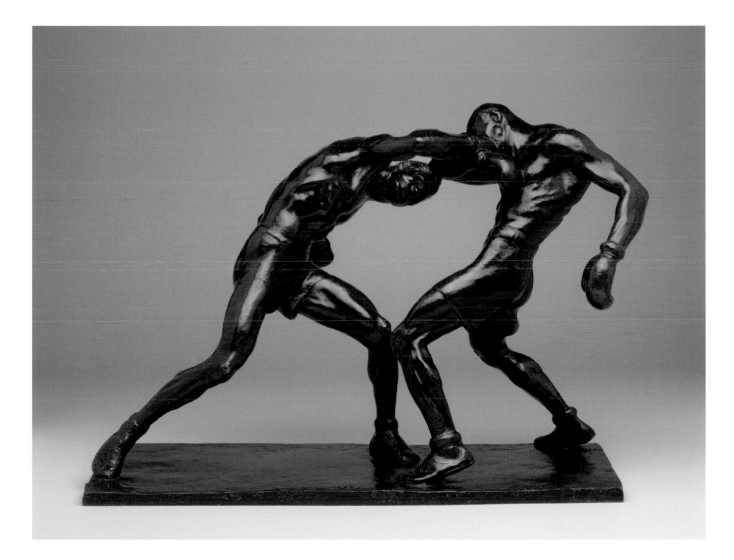

Raphael Soyer (American, born Russia, 1899–1987)

Café Scene, circa 1940
Oil on canvas, 24 x 20 in. (61 x 50.8 cm)
Gift of James N. Rosenberg, 46.15
© Estate of Raphael Soyer, Courtesy of Forum Gallery, New York

This scene of a solitary woman in a café is typical of Raphael Soyer's lifelong interest in the daily lives of working-class New Yorkers. Executed in his characteristic palette of somber grays and earthy hues, which add to the banality of the subject and setting, the work was based on a sketch Soyer made in a café. For the painting, he hired a model to re-create the pose in his studio, recognizable by the triple windows and radiator in the background. The man at left is a fellow artist, Julius Zirinsky (1898–1970), who happened to visit Soyer's studio that day.

Born in Russia, as were his two artist brothers, Moses (1899–1974) and Isaac (1902–1981), Raphael Soyer immigrated to New York in 1912. All three Soyer brothers focused on urban life and scenery in their art. Raphael liked to depict the blank expressions of people lost in thought, leaving the meaning of the scene open to the viewer's own interpretation. Sometimes his paintings included more pointed social commentary: in the 1930s his figures were seated in employment-office waiting rooms, and in the early 1940s his solitary women, such as the one in *Café Scene,* suggested the absence of husbands or sweethearts who had been called up for the war effort. Throughout his career, Soyer's subjects conveyed a sense of weariness and disquiet—a mood related to the social alienation of modern urban life. MS

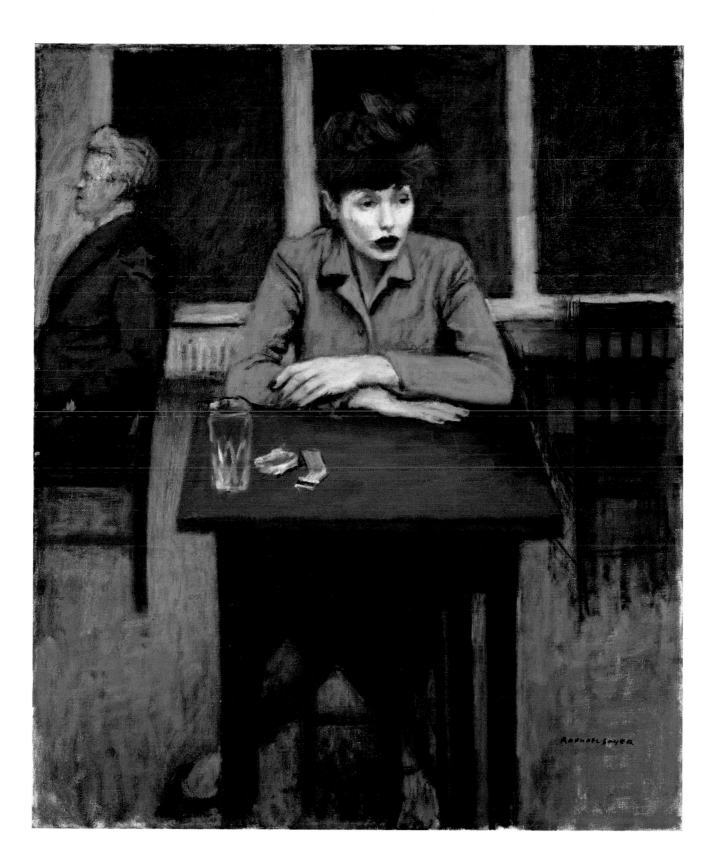

Reginald Marsh (American, 1898–1954)

Grand Windsor Hotel, 1946
Egg tempera on Masonite, 39⅞ x 33¾ in. (101.3 x 85.7 cm)
Gift of the Estate of Felicia Meyer Marsh, 79.85.2
© 2011 Estate of Reginald Marsh / Art Students League, New York / Artists Rights Society (ARS), New York

The murky palette of this painting evokes the character of the Bowery on New York City's Lower East Side. Cast in shadow by the elevated train, this once-celebrated theater district was the haunt of alcoholics, indigents, and prostitutes for much of the twentieth century. As described by the *New York City Guide* in 1939, it was an area of "pawnshops, restaurant equip-

FIG. 15. Reginald Marsh (American, 1898–1954). *Burlesque* (verso of *Grand Windsor Hotel*), 1946. Egg tempera on Masonite

ment houses, beer saloons, and miscellaneous small retail shops . . . [with] flophouses [that] offer a bug-infested bed in an unventilated pigeon-hole for twenty-five cents a night. . . . Thousands of the nation's unemployed drift to this section and may be seen sleeping in all-night restaurants, in doorways, and on loading platforms, furtively begging, or waiting with hopeless faces for some bread line or free lodging house to open."[1]

Early work as an illustrator for New York newspapers and magazines made Reginald Marsh a prolific sketcher and an astute observer of urban life. He was particularly drawn to the city's grittier side—its bustling streets, burlesque theaters, Coney Island bathers, and derelicts. According to his friend and fellow artist Edward Laning (1906–1981), the bum was a "figure of failure" and "a perennial element in the American mythology" who evoked compassion in the Yale-educated Marsh.[2]

In direct contrast to the broken-down Bowery denizens, a voluptuous beauty strides through the scene in *Grand Windsor Hotel.* A regular character in Marsh's works, she recalls the popular screen starlet of the 1930s, reminding us of the extremes of success and failure of the American dream. A seedier version of the blonde bombshell—the striptease artist—is depicted in *Burlesque,* on the reverse of this double-sided painting (fig. 15). MS

1. *New York City Guide* (New York: Random House, 1939), 120.
2. Edward Laning, comp., *The Sketchbooks of Reginald Marsh* (Greenwich, CT: New York Graphic Society, 1973), 48.

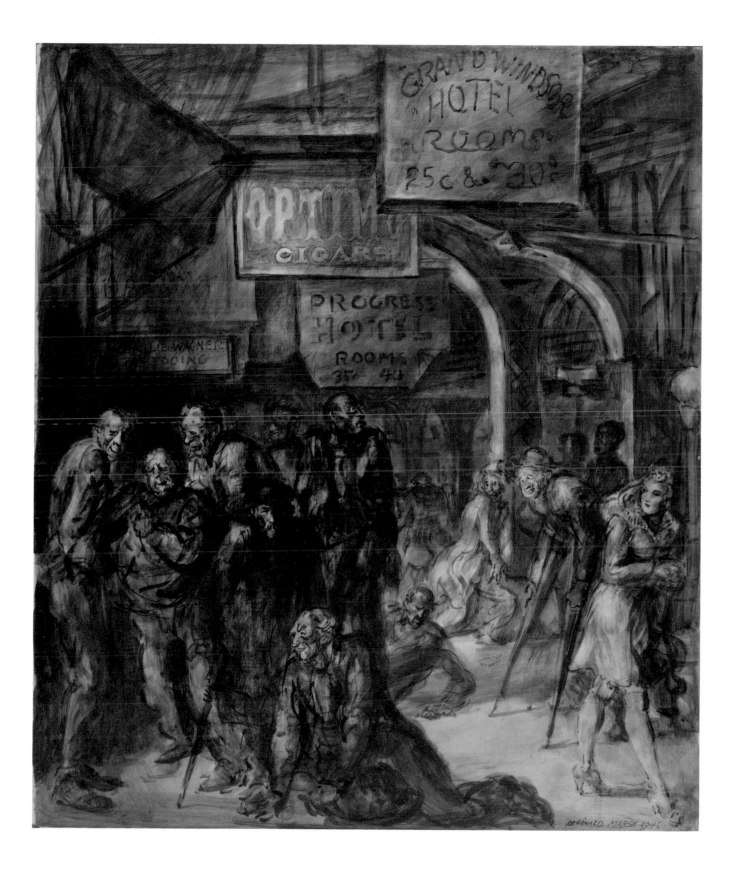

Jack Levine (American, 1915–2010)

Welcome Home, 1946
Oil on canvas, 39¹⁵⁄₁₆ x 59¹⁵⁄₁₆ in. (101.4 x 152.2 cm)
John B. Woodward Memorial Fund, 46.124
© Estate of Jack Levine / Licensed by VAGA, New York, NY

Shortly after returning from service in World War II, Jack Levine painted this scathing satire of a welcome-home dinner for a major general at a posh restaurant. Disillusioned with the army, Levine viewed the institution as an undemocratic "caste system" that placed "the big slob who is vice-president of the Second National Bank and president of the Chamber of Commerce" in a position of authority.[1] Using expressive brushwork and touches of garish color, he depicted the officer and his civilian companions with distorted features and mottled flesh in order to convey the ugliness of their characters. (The cadaverous appearance of the woman seems particularly incongruous with her fashionable attire.) Oblivious to the attentions of a waiter pouring champagne, these figures exude varying states of boredom, self-absorption, and psychological isolation. The claustrophobic space created by the tipped-up angles of the floor and table further heightens the discomfort of this cheerless celebration.

Levine's artistic approach combined a caricatural style indebted to Honoré Daumier (1808–1879) and George Grosz (1893–1959) with an interest in rigorous technique and moralizing narrative inspired by the Old Masters. Committed to making art that had social relevance, Levine began targeting injustice and corruption in contemporary America for pictorial critique in the 1930s. *Welcome Home* secured his notoriety when it was included in an exhibition of American paintings sent to Moscow in 1959 during the Cold War. Several congressmen were among those who objected to its unflattering portrayal of the US Army, and they unsuccessfully summoned Levine to appear before the House Un-American Activities Committee on suspicion of harboring Communist sympathies. KAS

1. Jack Levine, quoted in Stephen Robert Frankel, ed., *Jack Levine* (New York: Rizzoli, 1989), 41.

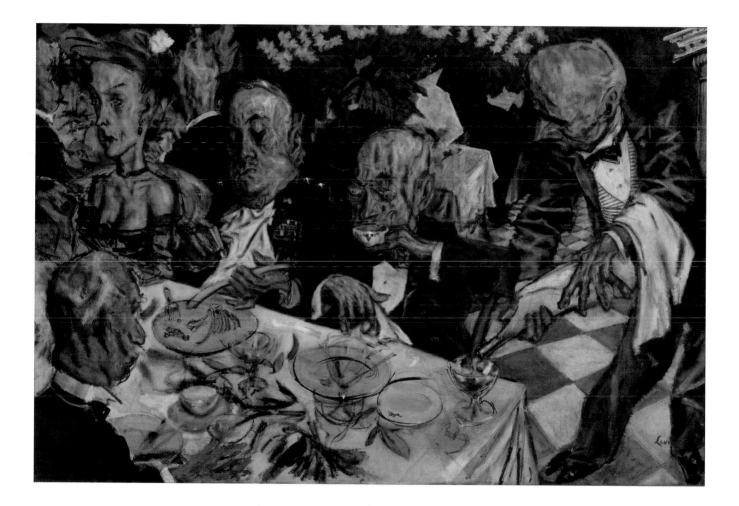

Ernest Crichlow (American, 1914–2005)

Shoe Shine, 1953
Oil on Masonite, 16⅟₁₆ x 12⅟₁₆ in. (40.8 x 30.6 cm)
Gift of Daniel and Rita Fraad, Jr., 65.204.3

Shoe Shine is characteristic of Ernest Crichlow's Realist canvases, which depict the daily lives of black New Yorkers. Although the shoeshine boy has often been viewed as a cultural stereotype of poor black children, in Crichlow's sensitive portrayal he appears as a hardworking and introspective young man who, between customers, dreams of a more prosperous future. As Crichlow often asserted in interviews, he was dedicated to portraying the strength of his African American community.

In reality, shoeshine enterprises constituted one of the few business opportunities open to blacks throughout the first half of the twentieth century. Although poverty and discrimination may have forced them into menial labor, some of these young men parlayed their experience into establishing their own shoeshine businesses and entering other lucrative trades.[1]

Born in Brooklyn to immigrants from Barbados, Crichlow began his career as a commercial illustrator. With the encouragement of the sculptor Augusta Savage (1892–1962), who ran the Harlem Artists Guild, he studied fine arts at New York University and the Art Students League. During the Depression, Crichlow was employed as a muralist for the Works Progress Administration (WPA) and taught at the Harlem Community Art Center, where Savage was the director. He later credited his work with the WPA for his lifelong commitment to political activism and often portrayed adolescents who refused to be trapped by their circumstances. In addition to his work as a painter and teacher, Crichlow illustrated numerous children's books on topics ranging from African American history to contemporary life. MS

1. Jessie Carney Smith, "Shoe Shine Establishments," in Jessie Carney Smith, ed., *Encyclopedia of African American Business* (Westport, CT: Greenwood Press, 2006), 1:723–25.

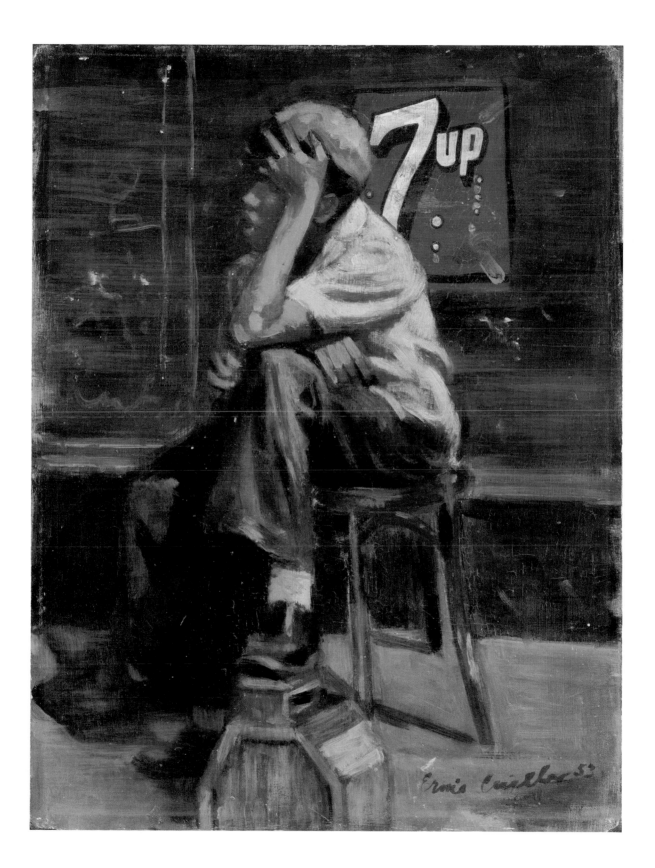

AMERICANA

Throughout the history of the United States, artists and writers regularly struggled to define what was distinctive about American culture, what set it apart from European traditions. This question arose with renewed urgency during the twentieth century, coinciding with phenomena such as the isolationism and loss of faith in Western civilization that followed World War I; the economic collapse and rise of European fascism during the 1930s; and the cultural nationalism and militarism fostered by the Cold War. At the same time, racism, poverty, labor unrest, and other social ills challenged patriotic assumptions about America's greatness. The search for "Americanness" in the arts took varied forms. Never an uncontested or unified endeavor, it was reflective of America's diversity, and it was not without its pernicious aspects, such as xenophobia. Some artists celebrated industrial products, the machine aesthetic, and the modern cityscape to express a national identity, while others posited alternative visions rooted in rural and small-town life and in heroic moments from the colonial past.

One manifestation of this quest for an authentic America was the rising appreciation for folk art beginning in the 1920s. Professional artists, dealers, and museums began to collect and exhibit the work of untrained artists who often practiced their craft outside the art establishment and who—like other "primitive" artists from Africa and non-Western cultures—were believed to have intuitive creative powers unfettered by artistic conventions. The decorative patterns and simplified forms characteristic of many folk objects also appealed to the modern aesthetic. In addition, twentieth-century folk art was celebrated as a continuation of amateur artistic practices (such as embroidery, wood carving, and decorative painting) that had thrived in America during the preceding centuries.

Amid a rapidly changing and challenging world, works of Americana such as those featured in this section offered comforting, nostalgia-infused images that evoked the past and simpler ways of life. Included here are illustrations made for popular publications, as well as folk art. The representational style and recognizable subject matter of these pictures often appealed to wide audiences, while also pointedly rejecting abstract currents in modern art that many Americans considered inaccessible, elitist, and foreign in origin.

Newell Convers (N. C.) Wyeth (American, 1882–1945)

Vision of New York, 1926
Oil on canvas, 48¼ x 32⅜ in. (122.5 x 82.2 cm)
Gift of the New York Telephone Company, 69.83

This painting illustrates a scene from Washington Irving's *History of New York* (1809), a satirical account of the Dutch in America during the seventeenth century. While shipwrecked on the southern tip of Manhattan, Oloffe Van Kortlandt has a dream in which Saint Nicholas, the patron saint of the voyage, reveals a vision of the island's future glories in the billowing smoke of his pipe. This dream inspires Van Kortlandt and his fellow settlers to build a city on this spot. In N. C. Wyeth's rendition, the Dutchman, perched in a treetop, gapes in wonder at spectral skyscrapers that materialize amid the lush forest greenery, while an elfin Saint Nicholas, sporting a fanciful costume and his characteristic snowy beard, nestles comfortably on a lower bough. The contrasting effects of the characters' attitudes, as well as of lights and darks, heighten the sense of drama.

Trained at Howard Pyle's (1853–1911) famous school of illustration in Wilmington, Delaware, Wyeth brought numerous classic stories—including *Treasure Island, Robin Hood,* and *The Last of the Mohicans*—to life for generations of readers with his realistically rendered and historically accurate images. Although he had a traditional academic background in draftsmanship and anatomy, Wyeth incorporated a more modernist approach in the 1920s, applying paint in unblended daubs of color, as in this work. *Vision of New York* appeared as an advertisement for the New York Telephone Company, whose newly completed office building soared above the skyline of lower Manhattan.[1] KAS

1. *American Architect* 130, no. 2509 (Nov. 20, 1926), facing p. 387.

Norman Rockwell (American, 1894–1978)

The Tattoo Artist, 1944
Oil on canvas, 43⅛ x 33⅛ in. (109.5 x 84.1 cm)
Gift of the artist, 69.8
Printed by permission of the Norman Rockwell Family Agency Book Rights
© 1944 The Norman Rockwell Family Entities

Reproduced on the cover of the March 4, 1944, issue of the *Saturday Evening Post,* this painting gently pokes fun at an American sailor who wears his fickle love life on his arm in the form of a tattooed list of girlfriends. Trying to hold still, he glances nervously down at his arm while a tattoo artist updates this list by inking "Betty" below the crossed-out names of former sweethearts. The ethnic variety of names, including Olga, Rosietta, and Ming Fu, attests to the international travels of a navy man with a girl in every port. Norman Rockwell's naturalistic style, charming characterizations, and easily legible narratives of small-town life made him America's most beloved illustrator. (He created 317 covers for the *Post* between 1916 and 1963, as well as imagery for other popular magazines.) To achieve his exacting realism, evident here in such details as the cushion's frayed threads and the sailor's sunburned face, Rockwell relied heavily on photographs and preparatory studies. He enlisted friends and neighbors in Arlington, Vermont, as models—here, Clarence Decker, a farmer, for the sailor (fig. 16) and Mead Schaeffer (1898–1980), another illustrator, for the tattooist. As further preparation, Rockwell also visited a tattoo parlor in New York City's Bowery district to study the process and its equipment.[1]

While Rockwell's images are generally perceived as straightforward reflections of American life, they frequently demonstrate greater complexity. *The Tattoo Artist,* for example, subtly alludes to contemporary aesthetics—in particular, modernism's interest in decorative patterns and the flatness of the picture plane—by suspending the figures in front of a wallpaper-like background of tattoo designs. KAS

FIG. 16. Gene Pelham (American, 1909–2004). Reference photo for *The Tattoo Artist,* modern print from 1944 negative. Photograph, 4¼ x 3¼ in. (10.8 x 8.3 cm). Norman Rockwell Museum Collections, Stockbridge, Massachusetts, Norman Rockwell Art Collections Trust. Printed by permission of the Norman Rockwell Family Agency Book Rights © 1944 The Norman Rockwell Family Entities

1. Rockwell provided information about *The Tattoo Artist* in an undated letter to Thomas Buechner, director of the Brooklyn Museum from 1960 to 1971. The artist's sense of humor is evident in his claim that Schaeffer "always said I exaggerated the size of his rear end." Curatorial file (69.8), American Art, Brooklyn Museum.

Morris Hirshfield (American, born Russian Poland, 1872–1946)

Girl with Dog, 1940
Oil on canvas, 34 x 26¼ in. (86.4 x 66.7 cm)
Bequest of Margaret S. Lewisohn, 54.157
© Robert and Gail Rentzer for Estate of Morris Hirshfield / Licensed by VAGA, New York, NY

This charming painting of a young woman walking a dog of indeterminate breed typifies the style and subject matter of Morris Hirshfield. The figures are rendered as simplified, strongly outlined forms, with little regard for anatomical accuracy (the appendages, in particular, are disproportionately small). Every inch of the canvas, including the stylized bushes and cloud-filled sky of the background, is laboriously crafted: the dog's woolly fur is described with tight, individual brushstrokes, and the woman's face is built up with paint so that it projects in sculptural relief.

The artist's interest in patterns and textures reflects his expertise with textiles gained over the course of a long career in the garment industry; Hirshfield eventually ran a leading footwear manufacturing company. After retiring, he took up painting as a pastime in the late 1930s. *Girl with Dog* is one of about seventy-five pictures that he completed during the final decade of his life. Unschooled in art, Hirshfield sought advice from John Baur, the Brooklyn Museum's curator of paintings, who encouraged his work and put him in touch with a gallery.[1] Through the passionate promotion of Sidney Janis, a collector of modern and folk art, Hirshfield's paintings were exhibited at the Museum of Modern Art and other prominent venues. Although several critics questioned his legitimacy as an artist (one complained, "Enough is enough of an oddity. It's the lost sense of proportion by [the museum] in giving all of the ground floor main gallery to the fumbling old man who hasn't an idea *why* they like him"[2]), many others admired Hirshfield's originality and bold design sensibility. KAS

1. This was Hudson Walker's Manhattan gallery, where Sidney Janis first saw Hirshfield's painting.
2. Maude Riley, "Tailor-Made Show Suits Nobody," *Art Digest* 17 (July 1, 1943): 15.

Anna Mary Robertson Moses (American, 1860–1961)

Early Skating, 1951
Oil and tempera on Masonite, 17¹⁵⁄₁₆ x 24 in. (45.6 x 61 cm)
Gift of the estate of R. Thornton Wilson, 83.122.2
© 1973 (renewed 2011) Grandma Moses Properties Co., New York

Early Skating is one of more than 1,500 paintings made by Anna Mary Robertson Moses—better known as Grandma Moses (fig. 17)—that depict the seasonal activities and landscape of her rural community in upstate New York. Children skate on a frozen pond, men carry a log to a sawmill, and other people go about their business, all under a looming gray sky. As is characteristic of the artist's distinctive style, the action is concentrated in the lower half of the composition, and the figures are described in reductive shapes with minimal modeling and details. Moses enlivened this winter scene with textured brushstrokes and bright accents of color (as in one skater's red snowsuit). In an ingenious touch, she mixed glitter into the white paint for the snow on the tree branches to capture the crystalline properties of this element.

Moses began painting in her late seventies, after decades of working on a farm. Like Morris Hirshfield, another elderly self-taught artist (see page 122), this amateur painter was "discovered" by a New York City collector who saw her pictures on display at a drugstore in Moses's hometown. She had a meteoric rise to celebrity, exhibiting in national and international venues and receiving widespread media coverage. US presidents from Truman to Kennedy sent annual birthday greetings to "the nation's Grandma." Mass reproduction of her paintings on calendars, greeting cards, fabrics, and other commercial products also contributed to her popularity; *Early Skating*, for example, appeared on Christmas cards issued by Hallmark in 1952 and 1955. Amid challenging times, her pictures of simple rural life—as well as her homespun, optimistic personality—struck a chord with many Americans. Moses also appealed to those who found contemporary abstract art alienating or difficult to understand. KAS

FIG. 17. *Grandma Moses at Her "Tip-up" Table*, 1948.
© 1982 Grandma Moses Properties Co., New York.
Photo: Otto Kallir

SELECTED BIBLIOGRAPHY

Armstrong, Tom, et al. *200 Years of American Sculpture*. Boston: David R. Godine in association with the Whitney Museum of American Art, 1976.

Arnason, H. H., and Elizabeth C. Mansfield. *History of Modern Art: Painting, Sculpture, Architecture, Photography*. 6th ed. Upper Saddle River, NJ: Pearson Prentice Hall, 2010.

Baigell, Matthew. *The American Scene: American Painting of the 1930's*. New York: Praeger, 1974.

Carbone, Teresa A., ed. *Youth and Beauty: Art of the American Twenties*. New York: Brooklyn Museum in association with Skira Rizzoli, 2011.

Contreras, Belisario R. *Tradition and Innovation in New Deal Art*. Lewisburg, PA: Bucknell University Press; London: Associated University Presses, 1983.

Corn, Wanda M. *The Great American Thing: Modern Art and National Identity, 1915–1935*. Berkeley: University of California Press, 1999.

Cox, Neil. *Cubism*. London: Phaidon, 2000.

Davidson, Abraham A. *Early American Modernist Painting, 1910–1935*. New York: Harper and Row, 1981.

Doss, Erika. *Twentieth-Century American Art*. New York: Oxford University Press, 2002.

Fer, Briony, David Batchelor, and Paul Wood. *Realism, Rationalism, Surrealism: Art between the Wars*. New Haven: Yale University Press in association with the Open University, 1993.

FitzGerald, Michael C. *Picasso and American Art*. New York: Whitney Museum of American Art in association with Yale University Press, 2006.

Greenough, Sarah, ed. *Modern Art and America: Alfred Stieglitz and His New York Galleries*. Washington, DC: National Gallery of Art; Boston: Bulfinch Press, 2000.

Harrison, Charles, Francis Frascina, and Gill Perry. *Primitivism, Cubism, Abstraction: The Early Twentieth Century*. New Haven: Yale University Press in association with the Open University, 1993.

Haskell, Barbara. *The American Century: Art and Culture, 1900–1950*. New York: Whitney Museum of American Art in association with W. W. Norton, 1999.

Haskell, Barbara, and Ortrud Westheider. *Modern Life: Edward Hopper and His Time*. Munich: Hirmer Verlag, 2009.

Hills, Patricia. *Modern Art in the USA: Issues and Controversies of the 20th Century*. Upper Saddle River, NJ: Prentice Hall, 2001.

Lane, John R., and Susan C. Larsen, eds. *Abstract Painting and Sculpture in America, 1927–1944*. Pittsburgh: Museum of Art, Carnegie Institute, in association with Harry N. Abrams, 1983.

Levin, Gail, and Marianne Lorenz. *Theme and Improvisation: Kandinsky and the American Avant-Garde, 1912–1950*. Boston: Little, Brown, 1992.

Lucie-Smith, Edward. *American Realism*. London: Thames and Hudson, 1994.

Mecklenburg, Virginia M. *The Patricia and Phillip Frost Collection: American Abstraction, 1930–1945*. Washington, DC: Published for the National Museum of American Art by the Smithsonian Institution Press, 1989.

Montclair Art Museum. *Precisionism in America, 1915–1941: Reordering Reality*. New York: Harry N. Abrams in association with the Montclair Art Museum, 1994.

Stavitsky, Gail, and Katherine Rothkopf, eds. *Cézanne and American Modernism*. Montclair, NJ: Montclair Art Museum; Baltimore: Baltimore Museum of Art; New Haven: Yale University Press, 2009.

INDEX OF CATALOGUE WORKS